Boston
FREEDOM TRAIL

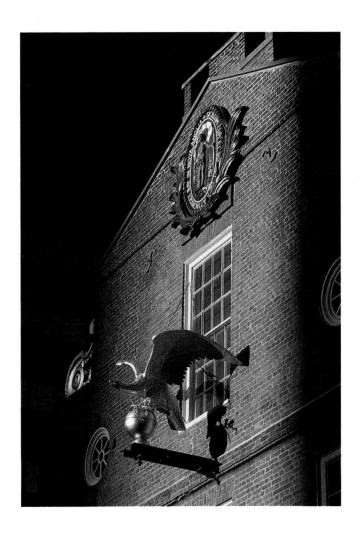

Photography by Steve Dunwell

Text by Blanche M. G. Linden

Back Bay Press

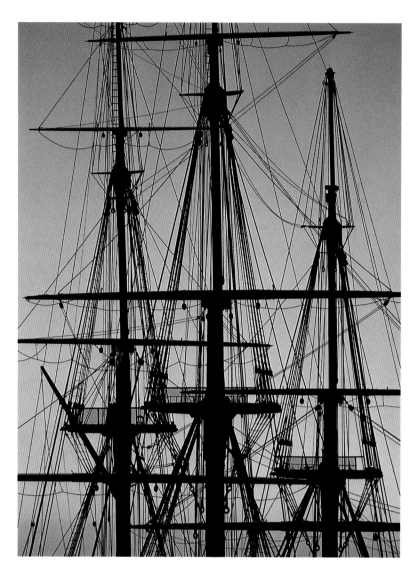

© 1996 Back Bay Press
Photographs © 1996 Steve Dunwell
Text © 1996 Blanche M. G. Linden

Design by Mark Rowntree

Special thanks to Angela K. Atwell
for editorial support.

Library of Congress #96–096194

ISBN #0-9643015-2-0

Second printing 1998

Printed in China

Published by Back Bay Press
20 Winchester Street
Boston, MA 02116

Historical image sources:

The Boston Athenaeum:
all monochrome portraits and autographs;
John Adams by Mather Brown; map 1775;
Revere's "Landing"; Bufford's view of
Beacon Hill; views of King's Chapel, Latin
School, Tea Party, Faneuil Hall, Copp's
Hill, and Bunker Hill.

The Museum of Fine Arts, Boston:
portraits of Adams, Hancock, and Revere
by J. S. Copley; Rachel Revere by
Dunkerly; "Bloody Massacre" by Paul
Revere.

Massachusetts Historical Society:
Old State House by J. B. Marston.

Boston Public Library:
Battle of Bunker Hill (from Barnard).

The Bostonian Society:
Park Street Church by H. Norcross.

The Concord Museum:
Boston Common by C. Remick.

The U.S.S. *Constitution* Museum:
battle with *Guerrière* by Schmidt.

From Jane H. Kay, *Lost Boston*:
Green Dragon Tavern.

Other views from *Boston Town* by
Horace Scudder, 1881.

Photograph page 1: The Old State House
Photograph page 2: U.S.S. Constitution

Contents

\mathcal{I}ntroduction

Boston 1760

James Otis (1725-1783) was Boston's "greatest incendiary." The British called his speech against the Townshend duties "the most violent, insolent, ...and treasonable declaration ever delivered." Otis and Samuel Adams, prime rabble-rousers of the Committee of Safety, proved central to the Patriot cause.

The Freedom Trail wends its way back into history along a route traveled by Puritans, Patriots, and generations since. Each era tried to establish, reform, or interpret its own notions of freedom. In trekking the Freedom Trail, try to visualize the scenes and hear the sounds of those times. Imagine the rich tones of church bells chiming, pealing, or tolling to muster Bostonians to worship or to fight fires, to witness executions or to attend funerals, to hear stirring Revolutionary oratory or to celebrate peace, or simply to mark the time of day.

Today's Freedom Trail has few traces of Puritan Boston; only its old burial grounds and its labyrinth of narrow, crooked streets remain. Great fires repeatedly wiped away the old, making way for the new: the blaze of 1711 destroyed the first Town House; the fire of 1760 obliterated 350 structures and ravaged Faneuil Hall. Few buildings survive from the colonial wooden town of half-timbered and gabled houses, taverns, and shops; Paul Revere's house, completed c. 1677, is the oldest now.

The Puritans founded their "Bible Commonwealth" in 1630 as a place where they could live their Calvinism. They equated Anglican rule with tyrannical persecution by ecclesiastical courts, and with forced tithing for a religion they could not abide. Yet their own vision of a religious sanctuary left no room for people of other faiths or beliefs. Puritans publicly punished transgressions against their stern laws. Crowds gathered near the Common's Great Elm to witness ritualized executions of witches, adulterers, pirates, and Indians. In 1659, Governor John Endicott condemned Quaker Mary Dyer and two male Friends to death for their beliefs.

Eighteenth-century Bostonians became more tolerant of diversity, more eager to expand freedoms, and more outspoken in defense of "natural rights"—new and untested Enlightenment concepts. Freedom meant liberty from arbitrary restraints or oppressive authority. In the name of liberty, Whigs in Old and New England opposed the Tory establishment.

Great social and legal inequalities existed in Boston at that time. Suffrage was limited to two-thirds of all adult white males — only about 2,500 out of the Town's 16,000. One in ten families owned a slave; selectmen failed to get the Province to abolish slavery in 1767. Indentured servants and apprentices bound for prescribed terms made up another subgroup. The disenfranchised, especially the "leather-apron boys," became increasingly vocal, swelling public meetings and mobs, voting with their feet for their own freedoms.

Activists called themselves Patriots and rowdily proclaimed their rights as Englishmen. Circumstances, time, and distance separated them from their mother country's interests. Demonstrations and violence escalated long before 1763, when major changes in British colonial policy brought "taxation without representation." As England battled the French and their Indian allies in 1747, the British Navy

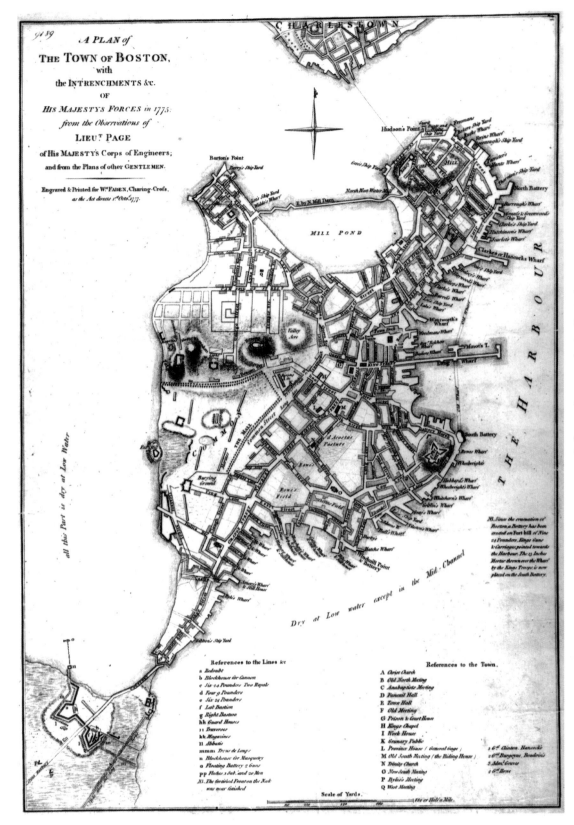

A PLAN of
THE TOWN OF BOSTON,
with
the INTRENCHMENTS &c.
OF
HIS MAJESTY'S FORCES in 1775;
from the Observations of
LIEUᵗ PAGE
of His MAJESTY'S Corps of Engineers;
and from the Plans of other GENTLEMEN.

Engraved & Printed for Wᵐ FADEN, Charing-Crofs,
as the Act directs 1ˢᵗ Octoʳ 1777.

This 1775 map of Boston shows British fortifications under siege by Patriots after the battles of Lexington and Concord. Most of the Town's 16,000 inhabitants had fled the Shawmut Peninsula, a site chosen in 1630 by Governor John Winthrop for the Puritan "City upon a Hill," precisely because it was virtually an island, linked to the mainland only by the Neck and thus easy to defend.

recruited by seizing men off Boston streets, mostly servants, apprentices, and laborers who were crucial to the Town's economy. Irate Bostonians fought back, led by Sam Adams's North End Caucus, a coalition of tradesmen; they held Crown officers hostage until the would-be sailors were released. Rabble-rousing got results, leaders like Adams and Paul Revere learned.

Dramatic changes in religion, politics, and community converged in the 1760s to set the stage for revolution. Boston's economy and population were stagnating. Only half of all children lived to adulthood, and epidemics ravaged young and old alike.

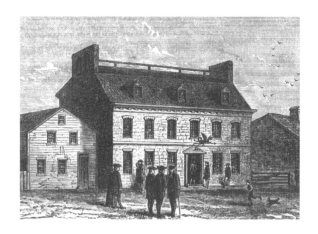

The old Green Dragon Tavern became "headquarters of the Revolution." The British dubbed it a "nest of treason" because Samuel Adams, James Otis, Paul Revere, and Dr. Joseph Warren rallied Patriots and planned the Tea Party here.

By the end of the French and Indian War in 1763, a third of all women had been widowed. To cut poor relief rolls, the Town farmed the indigent young out as indentured servants and consigned adults to the workhouse. Crime increased, and many "middling" families moved to nearby towns.

Few Bostonians were content or comfortable. Prices and taxes skyrocketed. The cost of wood rose so high that people stopped building, even to replace fire losses, and most of the Town's trees were cut down for fuel. Surplus printed money increased inflation, as silver flowed back to England when it was not used to fashion fine teapots for the wealthy few. The collapse of the Land Bank, engineered by Governor Thomas Hutchinson, ruined many Bostonians, including Samuel Adams's father. Sam described his Boston as the "Christian Sparta of America." Deprivation and rampant unemployment fueled the people's discontent. New and harsher British colonial policies ignited the tinder, and an angry mob ravaged Hutchinson's house.

The secretive and anti-authoritarian Sons of Liberty skilfully manipulated public opinion, staging street theatrics and fostering growing opposition to imperialism. Their florid, bombastic oratory heightened the long political debates raging at taverns, fueled by beer, hard cider, rum, and Madeira. Yet Yankees were also disciplined and trained, perfecting their own style of organized demonstrations and subversive preparedness. Tory Peter Oliver described one leader:

> Mackintosh paraded the Town with a Mob of 2000 Men
> in Two Files, and passed by the Stadthouse when the General
> Assembly were sitting to display His Power. If a Whisper was heard
> among his Followers, the holding up of his Finger hushed it in a Moment;
> & when he had fully displayed his Authority, he marched his Men
> to the first Rendezvous, & ordered them to retire peacefully to
> their several Homes; & was punctually obeyed.

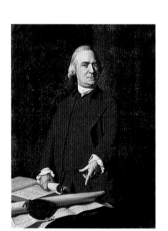

John Singleton Copley (1738-1815) depicted Samuel Adams at age fifty, as legal scholar turned protest leader. Adams (1722-1803), a Harvard-educated brewer's son, gained fame for opposing the Stamp Act and organizing the Sons of Liberty.

The 1765 Stamp Act, its impact worsened by economic depression, crystallized the public's discontent. Protests escalated into revolution as "The People" acted out their "just Resentment." Mobs and organized demonstrators shared the streets, hanging effigies and threatening tarring and feathering, or worse, to Crown officials deemed "Wretches unworthy to live," especially after the 1770 Boston Massacre. By 1773, local shops had sold out of guns, flints, and ammunition, and many bore arms. Yet most protests remained nonviolent, like the December 16 Tea Party, destroying property only. In 1774, General Thomas Gage asked for reinforcements to counteract locals who were "worked up to a Fury," not just Bostonians, "but Freeholders and Farmers of the Country" surrounding. Militia continued to train, and towns listed Minutemen on call for instant action, ready to draw munitions from secret stockpiles.

After the Tea Party, the British retaliated with the Intolerable Acts, closing the port and quartering four regiments in Town. Gage thought he could quell rebellion by occupying Boston. Local life ground to a halt as the New England Restraining Act curtailed fishing and shipping in 1775. The Massachusetts Assembly re-formed itself as the Provincial Congress, meeting in Concord. When Hancock's Committee of Safety hid munitions in outlying fields, the British set out in proud military order to seize them, unaware of the magnitude of organized resistance for miles around.

On April 19, the battles of Lexington and Concord stunned the British, leaving seventy dead and three times as many wounded. After retreating through a gauntlet of sniping Patriots, Redcoats hunkered down in Boston, trapped amid full-blown revolt. The Provincial Congress installed itself upriver in Watertown, commandeering private horses and wagons and coordinating about 30,000 militiamen ringing Boston. Britain's Prohibitory Act barred all trade and confiscated many ships, creating further animosity. Hancock and Sam Adams fled to Philadelphia, there to declare independence.

Chaos reigned throughout the winter of 1775–76. Boston, under siege, lay in shambles—commerce destroyed, buildings gutted, most inhabitants scattered to asylum in surrounding towns. A few thousand Loyalists remained, bolstered by Tory refugees from outlying areas. "Lobsterbacks" had to import food from Ireland and burn whatever they could find for fuel; the felled Liberty Tree produced 14 cords of wood. George Washington's new Continental Army trained a nine-mile artillery arc on the Boston enclave. The 59 cannon dragged from Fort Ticonderoga and Crown Point by Patriot General Henry Knox's men proved critical. British General William Howe promised Washington not to torch the entire Town if the troops and the Loyalists were simply permitted to evacuate to Halifax; and so they did on March 17, 1776, delayed by a severe late-winter storm.

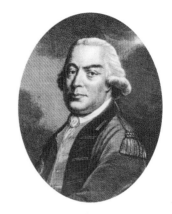

On June 1, 1774, General Thomas Gage (1720–1787) became governor, supplanting the native Thomas Hutchinson. Gage made many misguided decisions that fanned the flames of revolution.

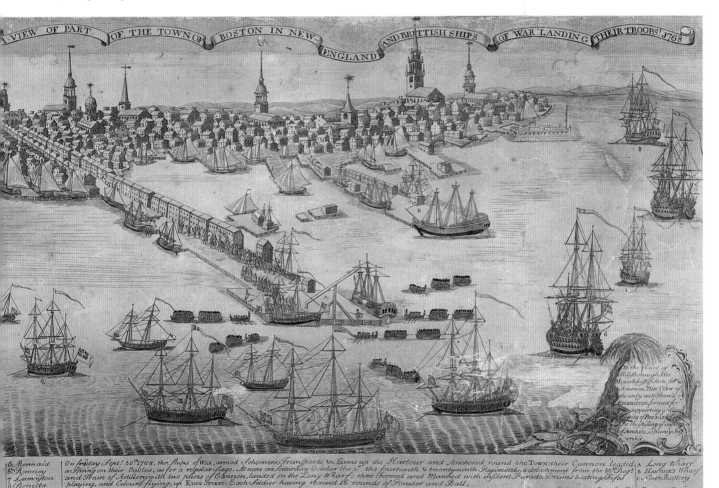

Paul Revere engraved the 1768 landing of British regulars after the 1770 Boston Massacre, deliberately exaggerating ships and steeples to heighten the sense of political conflict. Long Wharf, built in 1710, thrust out into the harbor, the chief thoroughfare of local economic prosperity. The Bunch of Grapes Tavern at its head was a favorite venue for Liberty Boys' agitation.

Boston Common

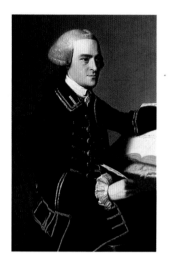

In 1764, Copley painted John Hancock (1737-1793), a year before Hancock became a vocal Stamp Act opponent. The wealthy merchant owned many ships, including the sloop Liberty, destroyed in 1768 for smuggling Madeira.

By 1640, Puritans had set aside the Common as a fifty-acre public space, a militia "trayning field," and a pasture "for the feeding of cattell." Peripheral to everyday life, it held the Town's granary, almshouse, workhouse, and a combined prison and insane asylum. Bells summoned crowds here for many public events, including executions. The evangelical minister George Whitefield preached the Great Awakening to a huge crowd in 1740, entreating his listeners to become the instruments of their own salvation, a revolutionary message that Puritans would not have endorsed.

Each annual Training Day, the militia paraded and held Drumhead Elections on the Common. In 1745, Governor William Shirley reviewed 2,000 volunteers set to march on France's Fort Louisburg in Nova Scotia, a major foray in the French and Indian War. News of success sparked a huge celebration; chiming bells and beating drums summoned the public for bonfires, fireworks, and libations. In 1758, the British camped 4,500 troops here before setting out to attack the French in upper New York; that campaign took a heavy toll on Bostonians.

Following the war, the Sons of Liberty opposed new imperial policies and held protests or celebrations here. When King George III repealed the Stamp Act in the spring of 1766, a jubilant crowd convened around a spectacular pyramid adorned by 280 lamps and Paul Revere's political cartoons. The crowd enjoyed fireworks and a 126-gallon cask of Madeira donated by John Hancock.

British regulars bivouacked here through 1775, cutting down most of the trees for fuel. After March 17, 1776, George Washington demolished their trenches and earthworks as a flotilla of 78 ships evacuated more than 8,900 troops and Loyalists. Most of the Common remained unsightly until after the War of 1812, when the Town turned it into a "pleasure ground" or "Mall" by laying new paths and planting new trees.

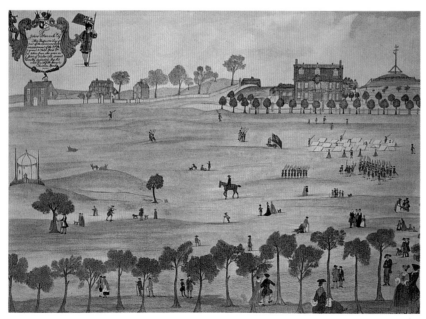

In 1768, Christian Remick drew the British troops bivouacked on the Common below John Hancock's mansion. The area remained rural and peripheral to Town life. The ancient hilltop beacon went unused, its role in giving alarm taken by lights placed in the Old North Church.

This aerial view of downtown Boston (opposite) shows th[e] Common (above ce[nter] and the Public Gar[den] (below). Freedom T[rail] sites are grouped a[t] apex of the Commo[n]

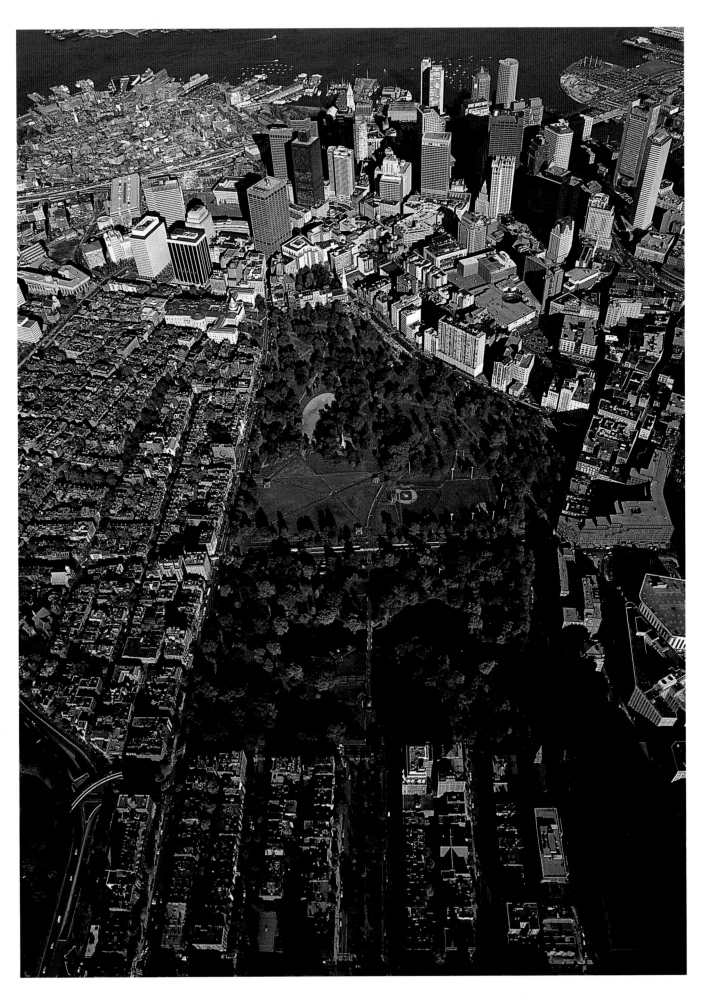

The State House

The Commonwealth replaced Revere's copper dome with 23-carat gold leaf in 1874, just in time for the centennial of American Independence.

After the Revolution, the Old State House seemed dowdy and run-down. It symbolized the colonial past, certainly not the new republican government in the making. Charles Bulfinch designed and sited a new, neoclassical structure meant to epitomize the power and permanency of self-government as Boston emerged from the war in an optimistic, expansive mood, no longer occupied and besieged.

After graduating from Boston Latin and Harvard, Bulfinch studied the architecture of Robert Adam and Sir William Chambers in England. Back home in 1787, he designed three churches, two state capitols, two monuments, a hotel, a theatre, and a dozen houses. Then financial reversals forced him to combine practice as a professional architect with service as Boston's chief of police and "Great Selectman."

Planning for the State House began in 1787, but political and economic problems created delays. Finally, Boston agreed to contribute most of the building costs ($133,333.33) to retain its position as capital. The Commonwealth chose Bulfinch's recommended site over one in South Boston, purchasing the land from Hancock's estate. Governor Samuel Adams laid the cornerstone on July 4, 1795, with Paul Revere serving as grand master of the Masonic ceremonies.

Simple white shingles covered the dome until 1802, when Paul Revere's new Canton foundry produced copper sheathing for it. The lantern atop the dome, 220 feet above sea level, was the town's highest point for decades—a grand landmark towering over the highest steeples, as if to symbolize the triumph of republican government over more repressive Puritan institutions. The "Great and General Court," the Commonwealth's legislature and governor occupied the building early in 1798, abandoning the Old State House to Town administration and, later, to other commercial uses.

Charles Bulfinch (1763-1844) designed the 60-foot Doric column topped by a golden eagle as a monument to Independence in 1789. From 1803 to 1811, teams of workers removed the top of Beacon Hill and dumped the gravel into the Mill Pond.

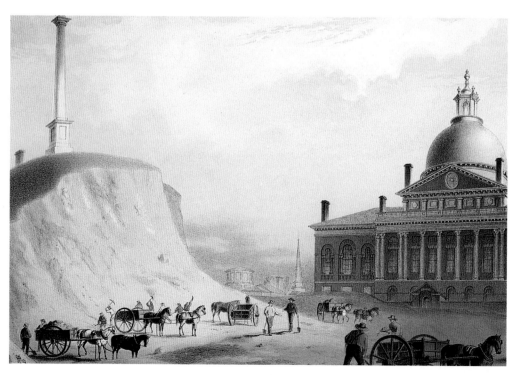

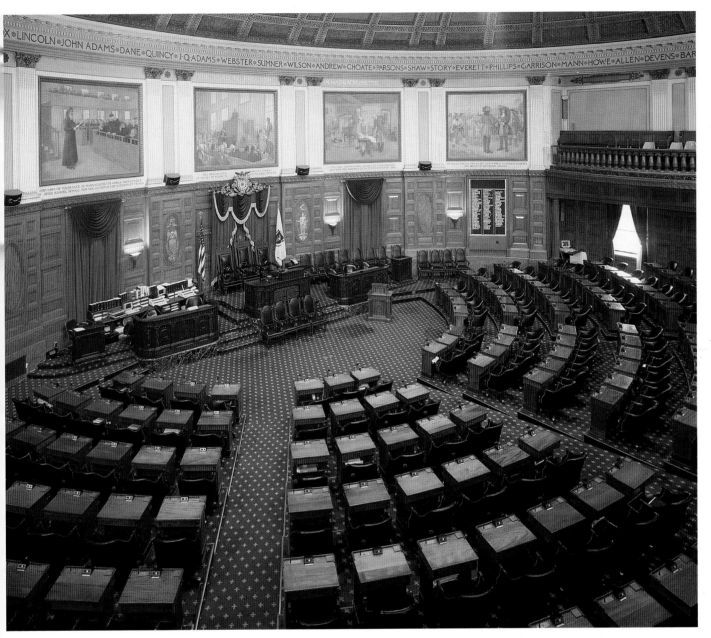

In 1804, Bulfinch laid out Park Street as a ceremonial approach to the State House. As governmental activity shifted here from the waterfront, Harrison Gray Otis and his agent, Samuel Cabot, purchased 15 acres of land belonging to famed painter John Singleton Copley and John Hancock's widow. In 1803, their Mount Vernon Proprietors began developing Beacon Hill into a dense but elite residential area, lowering it by fifty feet and using the gravel infill to create new land where the Mill Pond had been. By 1811, removal of the hill's crest gave the State House its visual dominance. Seen for miles around, it became the centerpiece for the city triumphant, a new Boston self-styled as the "Athens of America."

Since new Beacon Hill proprietors disliked seeing the poverty of the almshouse, Mayor Quincy moved it and the workhouse in 1824. A beautification campaign made the Common into a tree-lined park with a fashionable promenade. What had once been pasture was transformed into a vital, elegant setting for the State House and its surrounding neighborhood.

Bulfinch's original House of Representatives chamber was directly under the dome. The large wooden Sacred Cod, donated by merchant John Rowe, who owned a share in the Tea Party ships, hangs over the balcony to mark the economic importance of New England fisheries.

Park Street Church

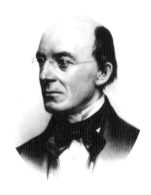

William Lloyd Garrison (1805–1879) delivered his first abolitionist speech at the Park Street Church on Independence Day, 1829. He condemned the Constitution as a "covenant with Death" because it institutionalized slavery.

The Park Street Congregational Church replaced the Town granary on the Common's eastern corner in 1809. The long wooden granary had stored corn, rye, wheat, and flour for sale to the poor until 1796, when Boston razed it to begin beautification of the area surrounding the new State House. Evangelical Congregationalists broke from the liberalizing Old South Church and hired British architect Peter Banner to design this brick Georgian structure with a 217-foot steeple, inspired by the latest London architecture.

Puritans would have been outraged to see the Old Granary, their secular burial place, next door to the new church, transformed into a churchyard. In 1823, the congregation built tombs under the sanctuary, selling them to members to defray the building costs. When the City banned burials in churches in 1862, these crypts were in "dilapidated and offensive condition," with brick walls caving in and coffins sitting deep in water.

Some say the Park Street Church was called "Brimstone Corner" because gunpowder was stored in the basement during the War of 1812. But others trace the name to the hellfire-and-brimstone sermons that the Rev. Edward Beecher and other orthodox Calvinist ministers preached here in the 1820s and 1830s. Either way, the Church epitomized the blending of past legacies with new ideas, the conservative with the liberal. Here, on July 4, 1829, William Lloyd Garrison delivered his first antislavery speech, "Dangers to the Nation," before the American Colonization Society. The struggle to expand notions of freedom developed new energy in the 1830s, led by Garrison and other Bostonians who braved mob violence for their efforts. In 1849, abolitionist Senator Charles Sumner spoke to the American Peace Society here on "The War System of Nations."

The Church was still new when this view was painted in 1810. Its rounded colonnades created a grand approach to Bulfinch's State House along the new Park Street.

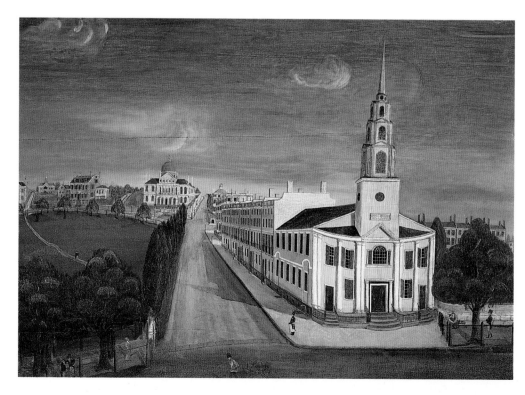

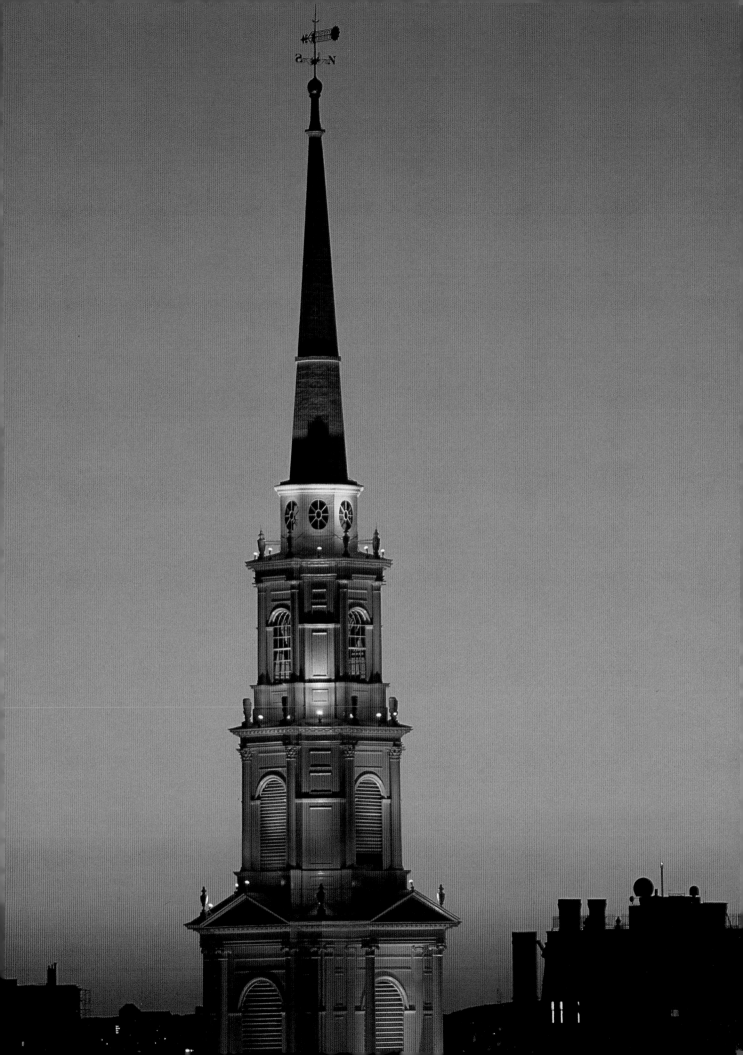

Granary Burying Ground

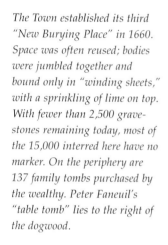

The Town established its third "New Burying Place" in 1660. Space was often reused; bodies were jumbled together and bound only in "winding sheets," with a sprinkling of lime on top. With fewer than 2,500 grave-stones remaining today, most of the 15,000 interred here have no marker. On the periphery are 137 family tombs purchased by the wealthy. Peter Faneuil's "table tomb" lies to the right of the dogwood.

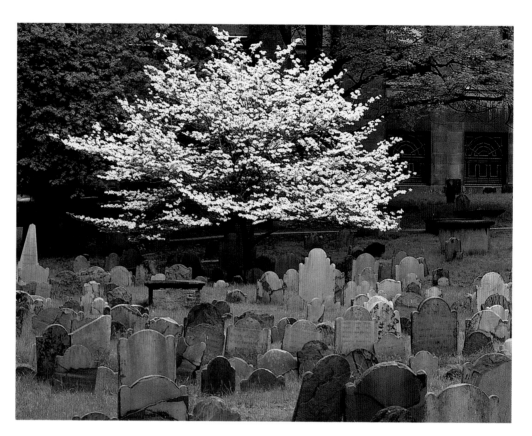

The Old Granary contains the earliest casualties of rebellion. The first to fall was 11-year-old Christopher Seider, struck down as anti-customs crowds took to the streets and Tories retaliated. For a moment, Seider symbolized the price of British tyranny. But eleven days later, on March 5, 1770, outrage over the killing of five demonstrators in the Boston Massacre brought anti-British sentiment to an even higher pitch. Thousands of Bostonians jammed the streets, following the victims' bodies here for burial.

In 1776, another patriotic throng carried the body of General Joseph Warren here. Dr. Warren, mastermind of Patriot espionage, had fallen at Bunker Hill a year earlier and had been buried in a common trench on the battlefield. In 1825, his nephew, Dr. John Collins Warren, removed his uncle's remains. Two years later, the younger Warren raised funds to erect a granite pyramid by Solomon Willard marking the tomb of Benjamin Franklin's parents.

Also buried here is James Otis, strident critic of the Writs of Assistance and delegate to the Stamp Act Congress. Otis was wounded by a customs officer in a 1769 tavern brawl; mentally impaired, he retired to a farm to sit out the Revolution he helped inspire. When lightning killed the fiery orator in 1783, a huge cortège led by Masons escorted his body to the Old Granary. Samuel Adams, another "grand incendiary," lies nearby. When Adams died in 1803 at age 82, a throng brought his coffin here, stopping at sites where he had exhorted the people to challenge tyranny. Not until 1898 did the Sons of the American Revolution place two massive boulders

of Roxbury puddingstone in these grounds to honor Otis and Adams, to symbolize the "bold and firm nature" of those "whose illustrious memory" they guard.

In 1793, the once-wealthy John Hancock, who spent his entire fortune after the Revolution, was placed in his family tomb with nothing to mark his crucial role in the fight for Independence. In 1895, the Commonwealth erected a tall neoclassical marble stele in Hancock's honor. Nearby is the simple stone of Frank, Hancock's manservant, a slave who died at age 38. Paul Revere, whose midnight ride sought to warn Hancock of the British approach to Lexington, lies close by.

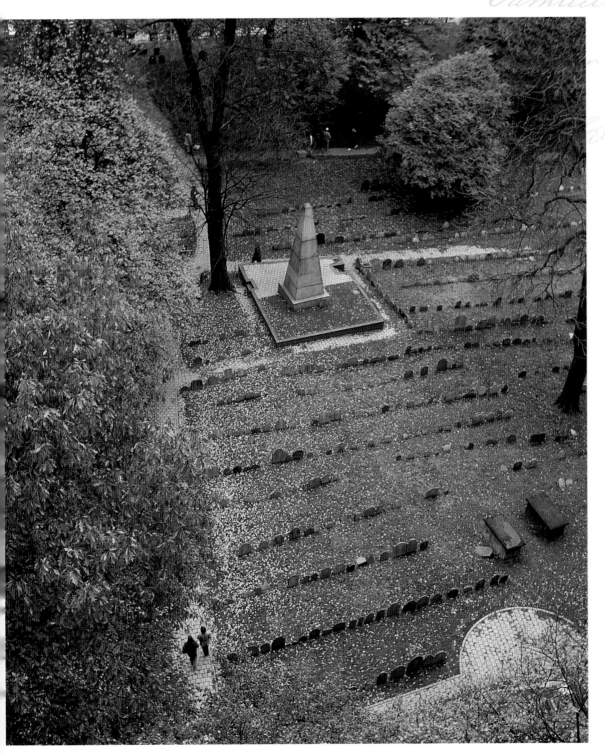

The pyramid (top) honors Franklin's parents. Revere's grave is near the semi-circle (right). Also buried here is Robert Treat Paine (1731–1814), who prosecuted British troops for the Boston Massacre and signed the Declaration of Independence.

15

King's Chapel

In 1684, King James II revoked the Massachusetts Bay charter and set up the Dominion of New England, uniting royal provinces in the northeast. Two years later his new governor, Sir Edmund Andros, introduced Anglican worship at the Puritans' Old South Meeting House. Horrified by this encroachment of "Popism," the Puritans refused to sell him other land. Andros defiantly seized part of the Town's first burying ground, displacing graves to build a small wooden structure called King's Chapel.

As the "Glorious Revolution" installed William and Mary on the throne and granted a new royal charter to Massachusetts, the chapel was dedicated in 1689 as Their Majesties'. For years, anti-Anglican vandals shattered its windows, a prelude to revolution fomented by the Rev. Increase Mather, who opposed extending religious toleration and the vote to all Protestants. Still, the Chapel expanded along with British authority.

By 1741, parishoners saw the need to replace the small, deteriorating building and commissioned Newport merchant Peter Harrison to design a new Georgian structure around it. Completed in 1754, this was the first stone church in the Province, with four-foot-thick walls of Quincy granite. The Town permitted the chapel's walls to extend farther into the graveyard, provided that 81 "bodies of bones" disturbed

This engraving of the "Old Burying Place" dates from 1833. Established by the Puritans in 1630 as a secular graveyard, it accommodated the victims of the "great sicknesses" that plagued the early Town. Buried here are Puritan Governor John Winthrop, the Rev. John Cotton, and Mary Chilton Winslow, the first English woman to set foot in New England when the Mayflower landed in 1620.

"be decently" reburied in "any one place as good as another." Workers dismantled the old structure, removing the parts through the new windows.

In the 1760s, Rector Henry Caner fueled anti-British sentiment by trying to convert Harvard College to Anglicanism, and by insisting that the English constitution established the Church of England in all colonies. Liberal ministers Jonathan Mayhew and Charles Chauncy launched a pamphlet war against such efforts to promote Anglicanism. According to John Adams, Mayhew fired "the opening gun of the Revolution" with sermons that boldly defended even regicide to curb tyranny. Caner and part of his flock left with other Tories in 1776, taking the chapel's treasure. The Revolution had religious as well as political roots.

Renamed Stone Chapel and closed for a time, King's reopened briefly for the grand funeral of Bunker Hill hero General Joseph Warren; then, beginning in 1778, the Old South congregation borrowed it for five years. Reopened in 1782, the Chapel later took back its old name, but this time it referred to the King of Heaven, rather than of England. The congregation, not British bishops, ordained lay

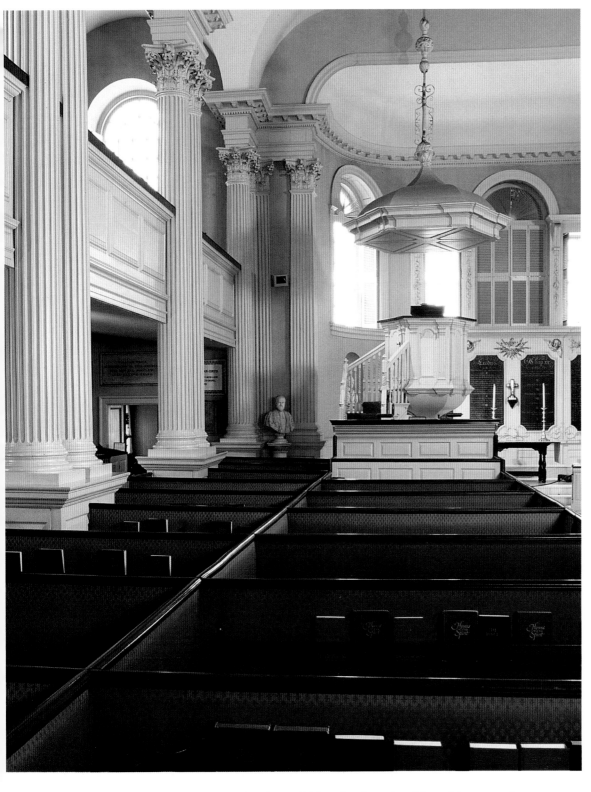

The would-be aristo-cracy came to services in fine carriages and the latest London fashions, and sat in family pews fitted with damask or velvet upholstery. Silver totalling 2,800 ounces, finely embroidered vestments, coats of arms, and ecclesiastical supplies were taken by the evacuating British, who left only the 1756 organ selected by Handel.

reader James Freeman, who was a theological liberal. Thus the Chapel became the nation's first Unitarian church.

In 1789, George Washington, clad in black velvet, attended an oratorio to raise funds for the chapel's portico of Ionic wooden columns, painted to resemble stone. In 1816, Paul Revere's foundry installed the deeply resonant "passing bell," which two years later would toll for its maker's burial at the Old Granary. Unfortunately, the bell was not in place in time for the burial of Revere's compatriot, William Dawes, in the burying ground adjacent to King's Chapel.

The Latin School

The Latin School was rebuilt after the expansion of King's Chapel (left). It stood from 1749 until demolished in 1844 to make room for City Hall.

Benjamin Franklin (1706–1790) was born on nearby Milk Street and baptized at the Old South. He attended the Latin School briefly.

In 1635, Boston established the first "public" Latin or Grammar School in America, resolving that Philemon Pormont, a shopkeeper, "be intreated to become a schoolemaster for the teaching and nourtering of the children with us." Pormont and his wife Susann taught classes in their home for two years, before Daniel Maude took over. In 1645, the Town built a small wooden schoolhouse on this site. That building was demolished in 1749 so that King's Chapel could expand; in return, the Anglicans constructed a two-story brick new Latin School.

By the 1760s, Boston had five schools. But they were not truly "public," providing only a small minority of Harvard-bound boys with a classical education. Boys aiming for an artisan's apprenticeship at age 13 attended Writing Schools and learned rudimentary arithmetic. Schools at that time served only about 525 boys annually. Infant or dame schools in private homes informally educated some children to age eight or so; two-thirds of all girls remained barely literate.

Nearby on School Street, coppersmith Joshua Brackett kept the Cromwell Head Inn, frequented by the Sons of Liberty. Its low-swinging sign with a portrait of Lord Protector Oliver Cromwell taunted Crown officials and Anglicans, who were obliged to duck their heads as they passed by on the narrow sidewalk. George Washington joined his fellow Patriots here to celebrate their victory after the British evacuated and he liberated the Town.

The Latin School remained here until 1844, when it was torn down to make way for City Hall. Statues of Benjamin Franklin and Mayor Josiah Quincy stand near the site of the school they once attended. Other notable alumni included Samuel Adams, John Hancock, and Robert Treat Paine, signers of the Declaration of Independence.

Old Corner Bookstore

Ideas have flourished at this site since 1636 when William Hutchinson occupied it and his wife Anne held religious meetings that led to her excommunication. Governor Winthrop judged her "a nimble wit and active spirit, a very voluble tongue, more bold than a man"— too radical and outspoken for patriarchal Boston ministers, who banished her and her fourteen children to Rhode Island in 1638. After the fire of 1711 destroyed the existing structure, apothecary Thomas Crease constructed this brick shop with second-floor living quarters under the deep gambrel roof.

The surrounding neighborhood became the "Cradle of American Journalism." In 1704, postmaster John Campbell began publishing the *News-Letter*, the colonies' first regular newspaper with excerpts from the English press. Near here, James Franklin's *New England Courant*, founded in 1721, published the scathing *Silence Dogood Papers* written by his young brother and apprentice Benjamin. When James landed in jail for thus offending local authorities, Benjamin fled to Philadelphia. Freedom of the press did not yet exist. Still, the *Boston Gazette*, begun in 1719 and housed nearby, became the forum for the Patriot cause after 1768. Its editors circulated diatribes by Samuel Adams, John Hancock, James Otis, and Joseph Warren.

Ten different bookstores and publishers have used this site since 1828. During the literary "Flowering of New England," it became known as "Parnassus Corner" under publisher William D. Ticknor. When Ticknor entered into partnership with James T. "Jamie" Fields, his former apprentice, it became a gathering place for their roster of noted authors, including Emerson, Thoreau, Margaret Fuller, Hawthorne, Julia Ward Howe, Longfellow, and Harriet Beecher Stowe. Conversations over claret spawned the influential Saturday Club and the *Atlantic Monthly*. Ticknor built a rear addition to house a press and added fine new shop windows. Braving controversy, in 1833, he displayed Lydia Maria Child's abolitionist tract, *An Appeal in Favor of That Class of Americans Called Africans*. When a racist mob smashed his windows, it was clear that not all Boston mobs advocated freedoms.

William D. Ticknor teamed with Jamie Fields in 1832 to found a publishing firm that fostered the literary "Flowering of New England." Ticknor used the second floor to publish the Atlantic Monthly.

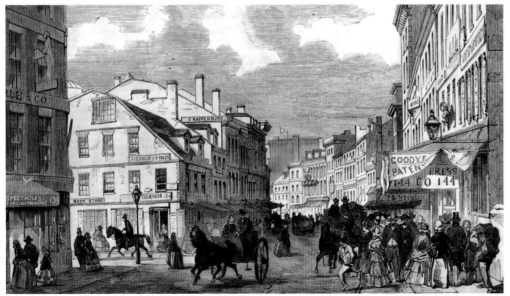

The bookstore, with its dormered gambrel roof and ground-floor bay windows, shows how eighteenth-century houses defined the tight streetscape. The area framed by School, Court, Tremont, and Washington streets bustled with activity fifty years after the Revolution, as Boston proclaimed itself the "Athens of America."

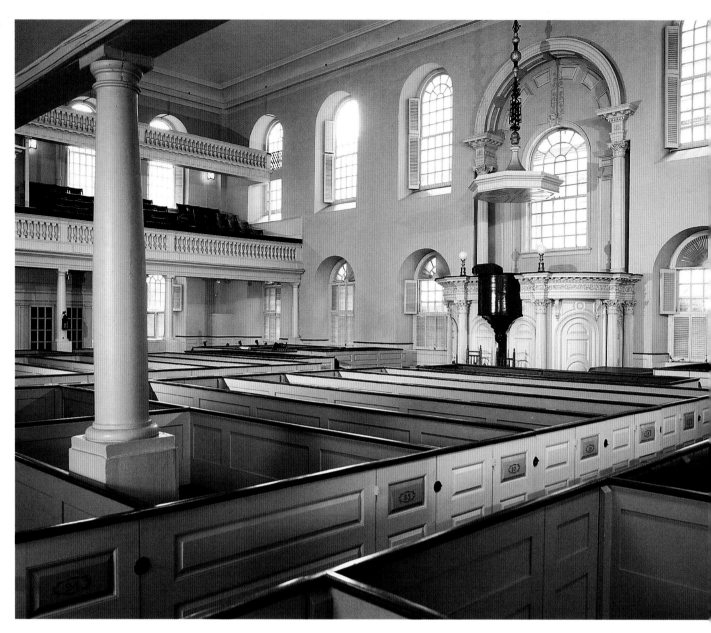

The spartan interior displays the fine craftsmanship of New England's shipbuilders, as do many New England churches. Here rich and poor alike listened to three-hour sermons covering news, politics, scandals, and quarrels as well as Calvinist doctrine.

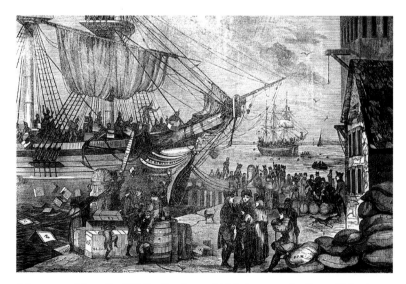

A huge crowd from the Old South witnessed high drama as the Sons of Liberty dumped 342 chests of tea into the harbor from the East India Company's ships *Beaver*, *Eleanor*, and *Dartmouth*.

Old South Meeting House

In 1669, a group of orthodox Puritans, opposed to the Half-Way Covenant's loosening of religious criteria for voting, formed a congregation in a simple, two-story, cedar structure on this site. Even in those early years the South Church served for Town meetings, as it would in 1682 when the Rev. Increase Mather summoned the public to consider Charles II's threat to revoke the Commonwealth's charter. When the charter was revoked four years later, under James II, the congregation rankled at Governor Edmund Andros's use of the Old South for Anglican services.

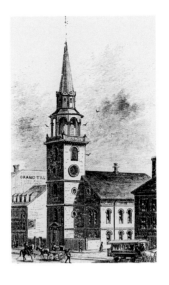

In 1729, master builder Joshua Blanchard completed a new brick structure on the site, giving the Old South the largest capacity for public meetings of any Boston building, including Faneuil Hall. The day after the Boston Massacre, Sam Adams convened a meeting here to demand removal of British troops. For the next five years, patriotic ceremonies at the Old South marked the anniversary of the Massacre.

A crowd of about 5,000, many from surrounding towns, gathered here on December 16, 1773, to discuss action against the three British East India Company ships docked at Griffin's Wharf. Liberty Boys vowed to block the decree to unload the cargoes of taxed tea. Royal Governor Thomas Hutchinson countered by refusing to let the ships leave full, and customs officials threatened to unload them forcibly at midnight. The meeting lasted from ten a.m. until late evening, the church dimly lit by candles as passions flamed.

Finally Samuel Adams exclaimed, "This meeting can do nothing more to save the country." On his secret signal, about a hundred men slipped away as prearranged. Reappearing with darkened faces and blankets, brandishing tomahawks, they cried, "Boston harbor a teapot tonight!" and headed down Milk Street; the mob followed, singing "Rally Mohawks, bring out your axes. And tell King George we'll pay no taxes." After dumping all 342 chests into the harbor, "making a little salt water tea," they shook out their pockets and shoes to show none had been stolen. As they marched back in rank-and-file order to the tune of fife and drum, the British admiral John Montagu taunted from his window, "Well, boys, you've had a fine evening for your Indian caper. But mind you have got to pay the fiddler yet!"

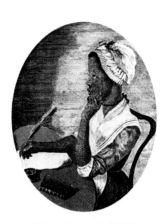

Slavers brought Phillis Wheatley (c.1753-1784) from Gambia, West Africa, at age seven to be sold as a maid. Her mistress, Susannah Wheatley, taught her to read and write, to study history and Latin. Phillis, a member of the Old South, became a renowned poet. Her first book, published in London, included "On America" and "Liberty and Peace."

Boston paid heavily for the "Tea Affair." The Intolerable Acts banned town meetings and mandated the quartering of British troops wherever they pleased. Towns for miles around passed resolutions in solidarity, "dreading the Slavery with which we seem to be threatened and being True Friends of Liberty." In 1775, crowds so packed the Old South that Dr. Joseph Warren, the speaker, had to use a ladder to climb in through a window. Redcoats in the audience taunted him throughout his oration, one of his last before he died at Bunker Hill.

After that battle, Boston families fled the occupied Town with whatever they could carry, leaving only about 2,000 Loyalists behind, while British regulars looted warehouses and homes. General John Burgoyne closed the port for a year and seized the Old South for the Light Horse Dragoons' riding practice, dumping sand on the floor and serving liquor in the gallery. Lobsterbacks confiscated the church records, burnt all but one pew for firewood, and used the last one to slop pigs. Such was Britain's audacious tyranny.

Old State House

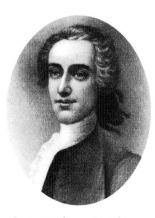

Governor Thomas Hutchinson (1711-1780) suffered mixed political fortunes. In 1760, John Adams wrote that "his countrymen loved, admired, rewarded, nay, almost adored him;" yet overnight, his fiscal policies ruined many Bostonians. In 1765, a mob wrecked his North End house, chanting, "Curse him! Let it burn!"

Boston's oldest public building, erected in 1713 overlooking Long Wharf, replaced an old wooden Town House dating from 1658. After the Great Fire of 1711, the Royal Province, Suffolk County, and the Town jointly financed a brick building with a room for the Elders' meetings, a library, an arsenal, and an arcaded farmers' market "for the Country people that come with theire provisions . . . to sitt dry in and warme both in colde raine and durty weather." It became the hub of the colony's trade. The stocks and whipping post stood outside.

The interior, built after a fire in 1747, features a staircase leading to the second-floor "seat of the Vice-Regal State of the Governors under the Crown," a small court chamber, and a middle room for Representatives of the Massachusetts Assembly, twenty-eight of "the most prominent and loyal friends of the King." A gallery in the Assembly Chamber allowed the public to watch government in action. Here, in 1760, crowds learned of the coronation of George III. One year later, James Otis declaimed against the Writs of Assistance (British search warrants to uncover contraband). His eight-hour oration so inflamed passions that the crowd went away "ready to take arms," recalled John Adams. "Then and there the child Independence was born."

A mob protesting the Stamp Act convened here in 1765, staging a mock funeral for effigies of British officials that had been hung on the Liberty Tree. Boston's board of nine selectmen met here repeatedly in late 1773, even on the Sabbath, to discuss how to deter violence over the tea tax, but failed to agree on means. Later, General Gage occupied the building, prohibiting its use for public meetings.

Jubilant crowds surrounded the ceremonial balcony on July 18, 1776, to hear the reading of the Declaration of Independence. In 1780, John Hancock, clad in his best red velvet coat and blue satin waistcoat, stood on the balcony as he became Massachusetts's first elected governor. Three years later, many gathered to hear of the Treaty of Paris ending the war. In 1789, President Washington paraded through a temporary triumphal arch to dine here, as the surrounding streets were renamed Washington and State. The building served as the State House until 1798, when the legislature moved to Beacon Hill.

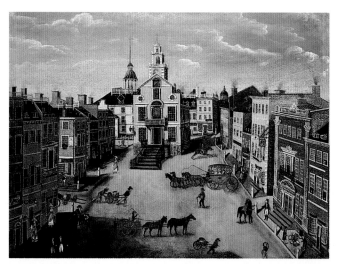

James B. Marston's 1801 painting, Old State House, shows the street widening into a public square in front. The building's various names— New Town House, Province House, Court House, City Hall, Temple of Liberty—reflected its many uses. The first floor contained the post office, provincial and county record offices, and a "merchants' exchange," a sort of stock exchange. The cellar housed a fire station, wine cave, and warehouse.

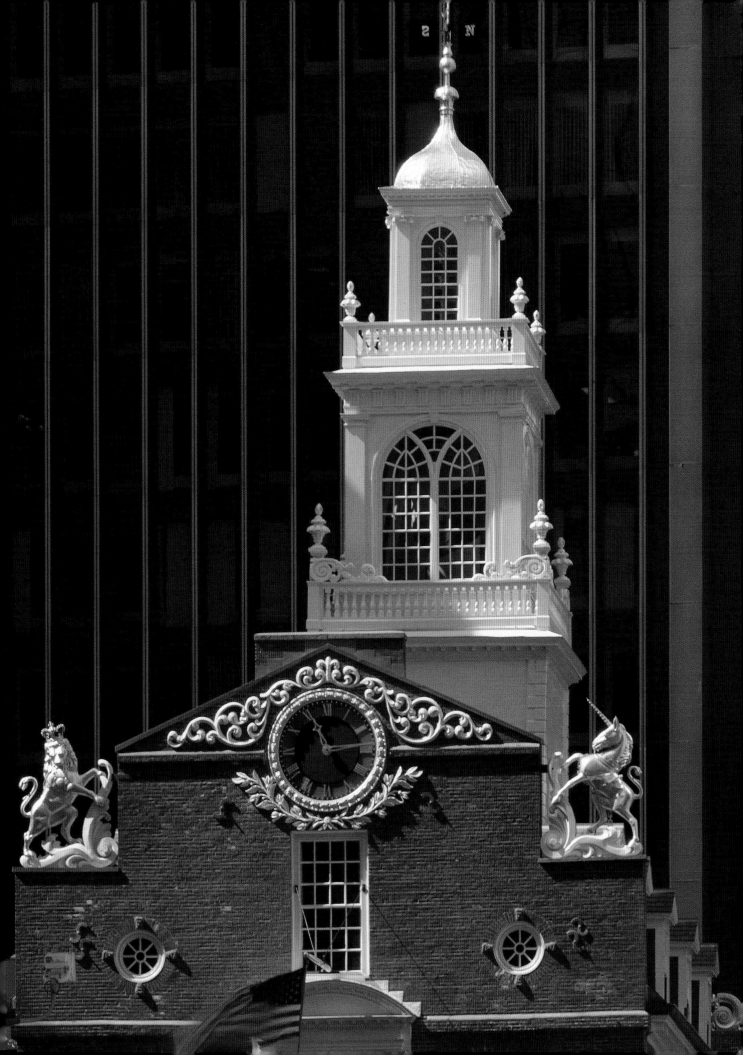

Boston Massacre

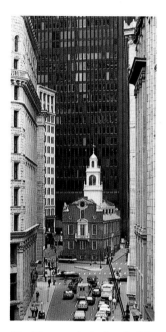

The Massacre took place just in front of the Old State House. The lion and unicorn, symbols of the British Crown, were torn down by a Revolutionary crowd celebrating Independence in 1776. More than a century later, the Bostonian Society replaced the sculptures when it made the Old State a historical repository.

On March 5, 1770, troops occupying Boston to enforce the new British taxes fired into a mob of about sixty rowdy Bostonians, wounding eight and killing five: Crispus Attucks, James Caldwell, Samuel Gray, Samuel Maverick, and Patrick Carr. Attucks, of both African and native American heritage, had escaped slavery in Framingham in 1750. Finding work in Boston, he called himself Michael Johnson to evade capture by his master. Maverick was apprenticed to Isaac Greenwood, instrument maker, ivory-turner, and dentist. Carr made breeches and Caldwell was a mariner. Gray, a journeyman on the ropewalks, had insulted a Redcoat a few days earlier, resulting in a tussle.

Mutual antagonism had escalated throughout the long winter, fueled by tavern brawls, back-alley fist fights, and petty court cases. That miserably cold, snowy, moonlit night, the mob converged on the State House, pelting British regulars with snowballs, rocks, and garbage. Captain Thomas Preston's regulars poked agitators with bayonets to disperse them, enraging the townspeople. Amid a volley of catcalls, Redcoats taunted Attucks, "You black rascal, what have you to do with white people's quarrels?" Three mobs converged, goading, "Come on, you rascals, you bloody-backs, you lobster scoundrels—fire if you dare, fire and be damned!" Bells rang out, just as they often did to summon Bostonians to save a burning house. Someone yelled "Fire!" The British did.

Three days after the Massacre, a procession of ten thousand, six abreast and carrying banners, led four of the five victims' hearses through the streets. As bells in Boston and neighboring towns tolled a "solemn Peal," the bodies of Caldwell and Attucks, "Strangers" without local families, were followed by "a numerous Train of Persons of all Ranks" from Faneuil Hall, where they had lain in state. Mourners bearing Gray and Maverick, who had lain in family homes, met up with the others at King Street, "the Theatre of that inhuman Tragedy!" Growing en route, the procession became "an immense Concourse of People" followed "by a long Train of Carriages" of "the principal Gentry." The throng laid the victims in a communal grave in the Old Granary Burying Ground, for many years marked only by a tall larch and a simple stone.

John Adams, Sam's lawyer-cousin, joined Josiah Quincy in a successful defense of the indicted regulars. John tried to exonerate Preston and eight of his troops by characterizing the mob as "a motley rabble of saucy boys, negroes and mulattoes, Irish teagues and outlandish jack tarrs." He also blamed British policy, stating "Soldiers quartered in a populous town will always occasion two mobs where they prevent one. They are wretched conservators of the peace." Two soldiers found guilty of manslaughter only had their thumbs branded. Yet at Sam Adams's insistence, British troops withdrew to Castle Island for two years after the Massacre. John Adams declared with hindsight, "On that night, the foundation of American Independence was laid"; and Daniel Webster added, "From that moment, we date the severance of the British Empire."

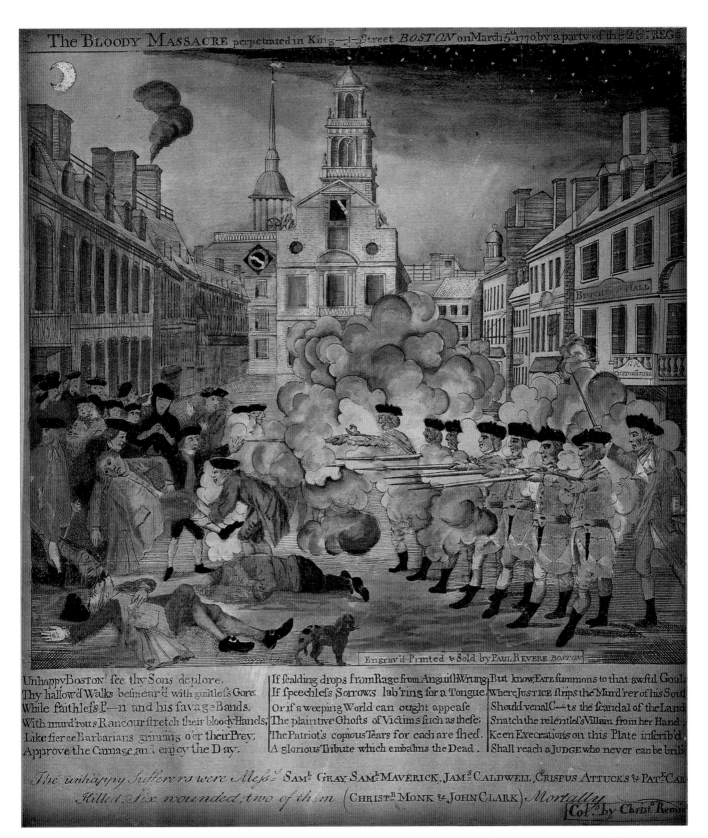

Paul Revere's Bloody Massacre Perpetrated in King Street, *printed two weeks after the event, was based on a drawing by Henry Pelham, John Copley's half brother, and colored by Christian Remick. The depiction of the fusillade is inaccurate: Preston's men were not in formation. Widely circulated throughout the colonies, this was the most inflammatory of Revere's many political drawings and cartoons.*

Faneuil Hall

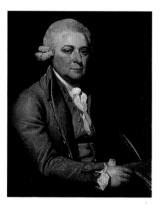

A gala event at Faneuil Hall celebrated the election of John Adams (1735-1826) as second president in 1797. Adams defended the British charged in the Boston Massacre.

Peter Faneuil, a Huguenot whose family fled French religious intolerance in 1685, went on to become Boston's wealthiest merchant. At his "own cost and charge" in 1742, Faneuil erected a two-story public market house designed by portrait painter John Smibert. The grand Georgian brick structure, 140 feet wide, replaced a wooden building that had been destroyed by a mob opposed to having a fixed commercial structure (they favored door-to-door peddling). The new building quickly supplanted the Town House as a bustling marketplace. Faneuil earmarked second-floor space for public meetings. "With utmost gratitude," the Town named the Hall for its benefactor. Sadly, the first oration given here was Faneuil's eulogy; the "jolly bachelor," "a fat, squat, lame man, hip-short with a high shoe," died at 42 of dropsy, a disease brought on by overindulgence.

Topped by Deacon Shem Drowne's famed grasshopper weathervane, made of 170 pounds of gilded copper and a symbol of the town's prosperity, the fine new building occupied a commanding position overlooking the docks. The Ancient and Honorable Artillery Company, America's oldest militia, took over a room in 1746. In 1761, when the building was destroyed by fire, a public lottery raised funds to reconstruct it.

Although the second-floor hall lacked the Old South Church's capacity, it hosted many Revolutionary gatherings. Samuel Adams called public meetings here to protest the 1764 Sugar Act and the 1765 Stamp Act. The Sons of Liberty frequently used it as a forum. Here, the outraged citizens gathered to protest the killing of five men in the Boston Massacre. It served as the "Acropolis of Boston," a marketplace of ideas and resistance. After the Revolution, the name "Cradle of Liberty" stuck.

Here, on November 22, 1773, Committees of Correspondence, summoned from nearby towns by Dr. Joseph Warren's call, formed a joint-action committee against the tea tax. On the 29th, broadsides beckoned the public: "Friends! Brethren! Countrymen! The Hour of Destruction or Manly Opposition to the Machinations of Tyranny stares you in the Face!" Bells brought out such a huge crowd that morning that it far exceeded the hall's capacity. So "The Body" of at least 5,000, including nonvoters and many from surrounding towns, marched to the Old South's larger facilities, jeering as they passed the Governor's Council meeting at the State House. The outcome of the marathon, day-long meeting was the Boston Tea Party two weeks later.

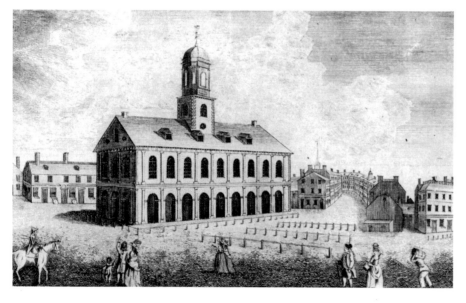

This "View of Faneuil-Hall in Boston" appeared in the new Massachusetts Magazine in 1789. Market space occupied the ground floor, with a grand Assembly Hall above. Shem Drowne's gold-plated grasshopper weathervane topped the central cupola.

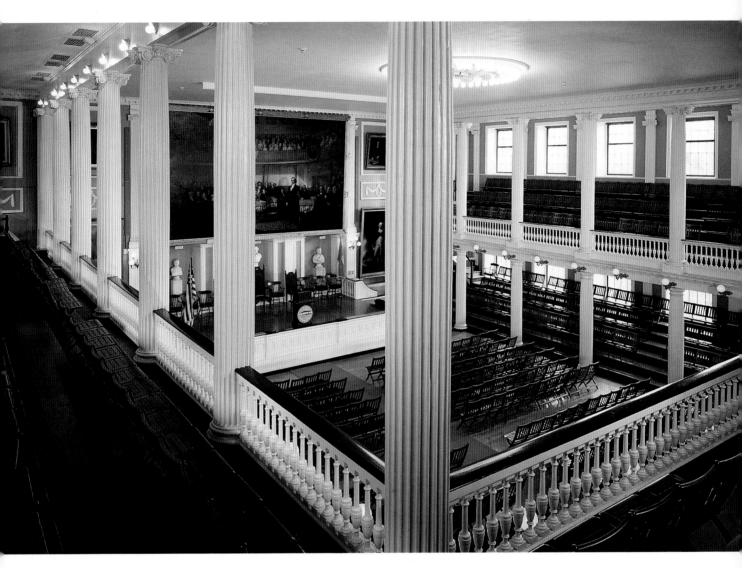

After Independence, Faneuil Hall became the site of grand patriotic celebrations instead of protests. In 1789, George Washington dined at a lavish banquet in the bunting-bedecked "Cradle of Liberty" during his triumphal return to Boston as America's first president.

In the quarter-century following Independence, Boston's population grew from 17,000 to 25,000. Although most households still had kitchen gardens, chickens, and cows, space for producing food dwindled rapidly. Existing market facilities proved insufficient for vendors from the surrounding countryside, whose numbers swelled after 1786, when the Charles River Bridge made the Town more accessible for farmers to the north. To address this problem, in 1805 Charles Bulfinch rebuilt Faneuil Hall, doubling its size at a cost of $56,700. Ionic pilasters and other fine architectural detail gave appropriate grandeur to a building that had become a patriotic shrine.

In the nineteenth century, Susan B. Anthony, Frederick Douglass, and other noted advocates of women's rights spoke here. Ironically, until women began to agitate for equal opportunities on the eve of the Civil War, they remained segregated in the galleries, watching the proceedings from afar.

In 1873, the Commonwealth commissioned Anne Whitney to produce a bronze sculpture (1880) of the defiant Sam Adams; it was placed in front of the town-side facade in 1928.

In 1805, Bulfinch enlarged the Assembly Hall with an extra floor and a gallery, making its capacity far greater than when overflow crowds listened to the fiery oratory of Sam Adams and James Otis in this "Cradle of Liberty."

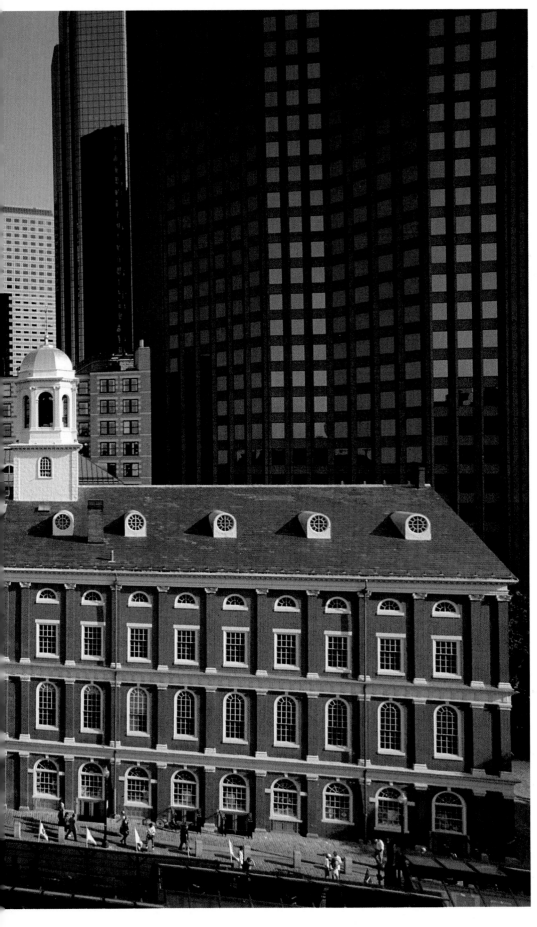

Bulfinch expanded Faneuil Hall with four bays and another story, enclosed the ground-floor market, and moved the cupola to the Dock Square gable end in 1805. Yet by 1824, Mayor Josiah Quincy realized that his newly incorporated City needed a larger market. He commissioned Alexander Parris to design a huge granite market in the then-fashionable Greek Revival style. Two stories high, 535 feet long, and covering 27,000 square feet of land, the new Quincy Market bustled with push-carts selling meat and produce.

Paul Revere House

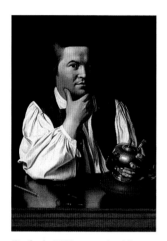

Copley's 1768 portrait of Revere (1734-1818) depicts the artisan, seven years before his famed midnight ride, in the typically American "plain style," without powdered wig. Revere's contemplative pose contrasted with conventional portraits of the bewigged, sedentary elite displaying their status.

In 1681, wealthy merchant Robert Howard bought a fine new two-story townhouse on the spot formerly occupied by the Rev. Increase Mather. By 1770, however, it seemed outmoded, as elite tastes favored the more fashionable Georgian architecture. Paul Revere, prospering as a silversmith, bought it for £214 and moved here from his Clark's Wharf residence.

Revere was far more complex than the "romantic hero" celebrated for his "midnight ride" or the "Lexington Alarm," made famous by Henry Wadsworth Longfellow's 1861 poem. His Huguenot father, Apollos Rivoire, Americanized the family's name. During the French and Indian War, at age 21, Paul received a commission as an officer and marched with 500 men against Crown Point at Lake George, New York. Unlike the many Bostonians who died in that war, Revere returned to become an artisan, entrepreneur, merchandiser, and political activist. The gold- and silversmith dabbled in dentistry. Many of his copperplate engravings and broadsides served as propaganda.

Revere earned a place in history not just for his fabled (though ill-fated) ride, but for his dogged work for the Patriot cause as activism escalated toward Revolution. Revere joined diverse groups that organized opposition to British policy. He was a prominent Freemason in Boston's St. Andrew's Lodge, which met at the Green Dragon Tavern, and a leader in the local Whig movement through many political clubs. Revere worshipped at the "New Brick" or Seventh Congregational Church. He rode as a courier bearing news and correspondence to New York and Philadelphia. His first ride, in 1773, informed other colonists of the arrival of the tea ships in Boston. Soon after, he rode again with news of the Tea Party, which he helped organize.

The Reveres' master bedroom probably occupied the front of the second floor. Other rooms in the rear of the house and on the third floor provided space for the many children borne by Revere's two wives.

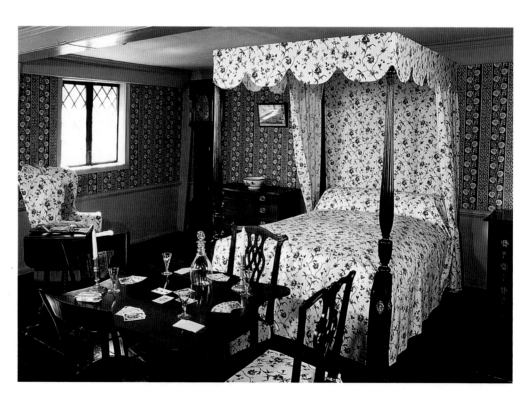

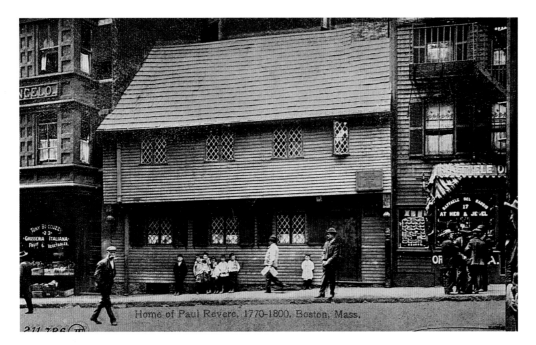

This 1907 postcard view of Revere's house shows the typical late-seventeenth-century dwelling, built close to the street with a second-floor overhang.

Yet his shorter "midnight" ride has become the stuff of myth. Patriots knew that the Lobsterbacks were preparing to march, 700 strong, to seize their stockpiled munitions along with their leaders, John Hancock and Samuel Adams, who were in Lexington. At ten o'clock on the night of April 18, 1775, Lieutenant Colonel Francis Smith led boatloads of Redcoats, rowing with "oars muffled to prevent a sound," from Boston Common to Cambridge while a warship guarded the river. Revere knew that the troops were crossing "by sea," and arranged for sexton Robert Newman to hang the secret signal of two lanterns in Old North Church steeple as a backup to alert others. Revere was rowed across the dark water to Charlestown, also with muffled oars, to sneak past the man-of-war *Somerset*. Borrowing a horse from Deacon Larkin, he set off via Arlington toward Lexington and Concord to alert his countrymen along the way that the British were coming.

William Dawes and numerous others also rode off, but along other routes, and some to other destinations. Dawes left Boston before Revere, via Boston Neck, and arrived in Lexington after him. After rousing Lexington Minutemen, Revere met Dawes and they took the road for Concord. Dr. Samuel Prescott, returning home from visiting his girlfriend, overtook and joined them enroute. Soon a British patrol stopped them, detaining Revere while his two friends escaped. Dawes lost his horse and only Prescott reached Concord to spread the alarm. Meanwhile, with ignorant bravado, the British regulars marched toward Lexington, taunting in song to the tune of "Yankee Doodle":

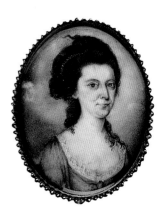

This miniature depicts Rachel Walker Revere (1745-1813), who became Paul's second wife in 1773, five months after the death of Sara Orne, his spouse of 16 years. Rachel bore eight children, only five of whom survived past childhood.

> *As for their King, John Hancock,*
>
> *And Adams, if they're taken,*
>
> *Their heads for signs shall hang on high*
>
> *Upon the hill called Beacon.*

Prepared and forewarned, the Patriots skirmished with the British on Lexington Common and "fired the shot heard around the world" at Concord's Old North Bridge. Militia mobilized for miles around. Watertown's 129 militia men received pay for two days' service plus mileage marched and rations of rum and biscuits.

Revere's 1806 letter solicited aid for fire victims, a cause he actively championed after the Revolution. These were his reading glasses and document box.

They arrived along with Newton men in time to form a gauntlet, sniping in a sort of guerrilla warfare at the British fleeing back to Boston. More than 200 fatigued British regulars lost their lives along the "Battle Road," thanks in part to Lord Percy of Northumberland, who dawdled in mustering his troops from Boston Common to aid the retreat.

News of the Lexington and Concord battles did not reach England until May 28. Still, Hancock immediately fled to Philadelphia, where he joined compatriots in declaring Independence the following summer. Revere remained a fugitive, finding shelter in Watertown along with Dr. Joseph Warren, *Boston Gazette* publisher Benjamin Edes, and other Sons of Liberty. He sent a smuggled letter to his wife, Rachel, telling her to pack up the children, his copper plates, and as many household goods as she could fit into a cart and join him. She made it out of town before General Gage declared martial law on June 12. In Watertown for more than a year, Revere printed money for the Massachusetts Provincial Congress, the first legal tender issued in Massachusetts in a quarter-century, in defiance of an act of Parliament. Rachel and other women made bandages for wounded Patriots and melted down any metal they could find to produce bullets.

The Reveres returned home only after Gage's troops and Loyalist sympathizers evacuated, but Paul would not settle down for another four years. From 1776 to 1779, he served as a lieutenant colonel of the state's Train of Artillery at Castle Island. In 1777, he escorted British prisoners of war from Worcester to Boston. Before his military career ended in 1779 with an ill-fated expedition to Maine, he took part in a failed campaign to expel the British from Newport.

With the war won, Revere returned to his many business pursuits and civic activities. By 1788, he had opened a foundry on Commercial and Foster streets in the North End, appropriately specializing in bells and cannon. He sold more than 400 bells of all sizes throughout the United States and abroad. Later, he built a copper mill in Canton, competing with British imports of sheet copper, manufacturing

In the spartan conditions of Revolutionary-era Boston, housewives like Rachel Revere relied on basic foodstuffs produced by their own kitchen gardens, if not purchased at local markets or from itinerant vendors. Rachel presided over "her sphere," cooking for her large family in the open hearth.

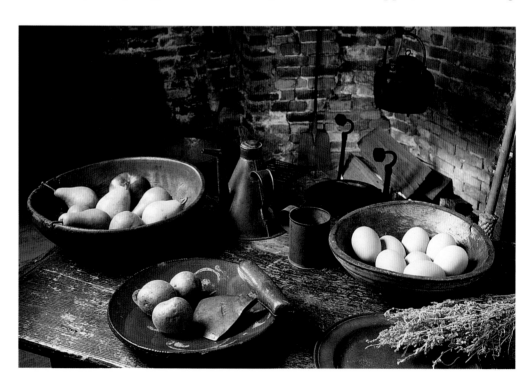

munitions, bolts, spikes, and nails. His copper mill produced the copper that covered Bulfinch's State House dome and sheathed the hull of the U.S.S. *Constitution* and other naval vessels; it also made the boilers for many of Robert Fulton's steam ships. During this period he also helped found the Massachusetts Mutual Fire Insurance Company to prevent fires, improve fire fighting, and aid those made destitute by conflagrations.

Amid all his activities, Revere made improvements to his house, but eventually it proved too small for his family. He sold the house in 1800 and moved to a larger house nearby. For many years a series of shops occupied the structure, which also saw use as a tenement. It was restored to its original condition in 1908, and survives as the oldest wooden building in downtown Boston.

This equestrian statue of Revere, riding to spread news and organize resistance, was sculpted by Cyrus Dallin in 1885. Cast in 1940, it stands on the mall behind the Old North Church.

Old North Church

In addition to the role it played in Paul Revere's ride, Christ Church or the Old North is notable for being Boston's oldest surviving religious structure. Boston's Anglicans, whose growing numbers could no longer fit into King's Chapel, commissioned the church in 1723. Although its architect remains unknown, the Georgian design was inspired by Sir Christopher Wren's St. Andrew's-by-the-Wardrobe in Blackfriars, London. Anthony Blount and William Price, a Boston engraver and a draftsman, supervised construction using Medford bricks.

The Old North housed Boston's first bells, indeed America's first, cast in Gloucester, England and ranging in size from 620 to 1,545 pounds. Their maker, Abel Rudhall, inscribed them: "We are the first ring of bells cast for the British Empire in North America, A. R. Ano 1744" and "God preserve the Church of England." The 15-year-old Paul Revere and six of his friends drew up a contract with the church wardens to provide regular bell-ringing and to be on call for special occasions such as sounding alarm.

Despite the Revolution, the Old North remains an Anglican shrine. Following Church custom, burial crypts are located in the basement. Major John Pitcairn, notorious for ordering his regulars to fire on Lexington Common on April 19, 1775, was placed in one such crypt. He was fatally wounded by the black Patriot Peter Salem at Bunker Hill on June 17, 1775, while rallying the Royal Marines. His own son carried him on his back from the field to the boats, then "kissed him and returned to

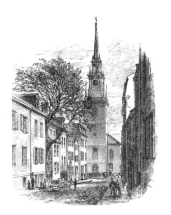

This view of Christ Church as seen from Copp's Hill dates from 1881.

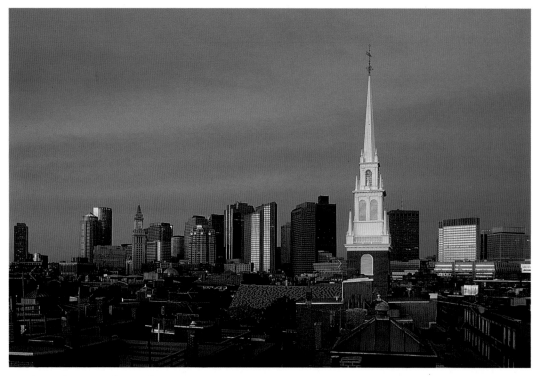

British Honduran merchants who traded frequently in Boston donated the Old North's first steeple, with weathervane by Shem Drowne. A gale toppled it in 1804. A second steeple stood until destroyed by Hurricane Carol in 1954. The current steeple dates from 1955.

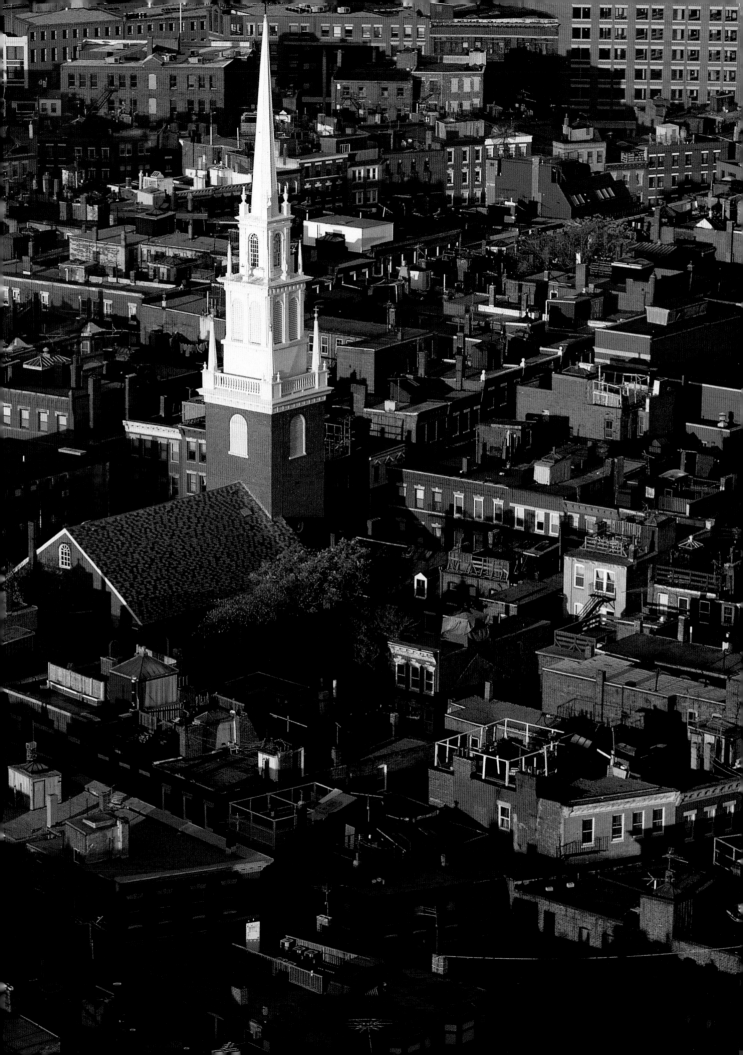

Robert Newman (1751–1804), sexton of the Old North, had help from Captain John Pulling and Paul Revere in hanging signal lanterns in the steeple on April 18, 1775. With British officers quartered in his mother's boardinghouse, Newman took great personal risk as he sneaked out a window to meet Revere, who then was rowed to Charlestown to begin his famous ride.

duty." Pitcairn died that day. Supposedly, his body was later moved from the Old North to Westminster Abbey, although records suggest that the bones of a Lieutenant Shea were mistakenly shipped back. Pitcairn may still rest here among more than a thousand adherents to the Church of England.

Still, Patriots treasured the Old North. A tablet honors Commander Samuel Nicholson (1743–1811), a Revolutionary veteran and member of the Massachusetts Society of the Cincinnati (former officers). He became the senior officer in the new U.S. Navy as first commandant of Charlestown Navy Yard and of the U.S.S. *Constitution*. Another plaque commemorates Captain Daniel Malcolm, whose store attracted Patriots for nonimportation meetings. In 1768, the merchant led the "Liberty Riot," protesting seizure of Hancock's sloop *Liberty* with its illegal cargo of Madeira. In 1769, he was "buried ten feet deep in Copp's Hill," near the Old North, "safe from British bullets." His marker there praises "A true Son of Liberty, a Friend to the Public, An Enemy to Oppression and One of the Foremost in opposing the Revenue Acts on America." Redcoats riddled the stone with bullets while occupying the strategic hill, as British troops used the site as an artillery battery to bombard Charlestown during the Battle of Bunker Hill.

Following Independence, the first monument to George Washington in Boston was erected in the Old North in 1815, a bust copied in Italy from Christian Gullager's 1790 original. On his return to Boston in 1826, the Marquis de Lafayette admired his friend's image, declaring, "Yes, that is the man I knew, and more like him than any other portrait."

Box pews lined the Old North, their high sides retaining the heat from foot-warmers filled with hot bricks or coals. The Honduran merchants' pew was lined with fine burgundy fabric.

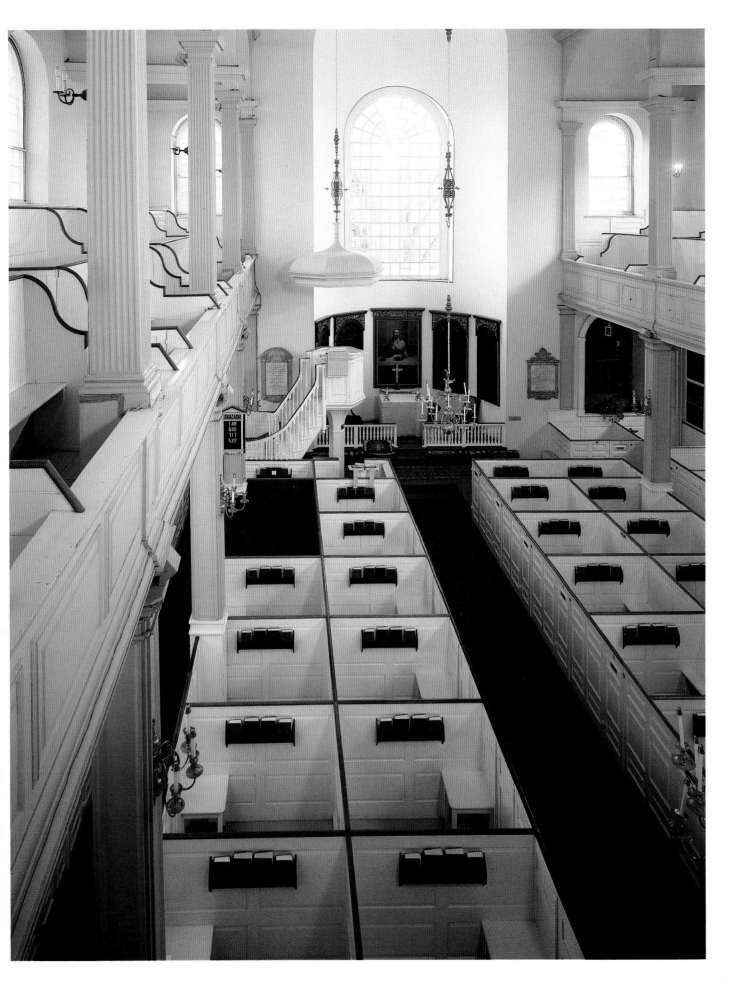

Copp's Hill Burying Ground

Mary Stevens's gravestone dates from 1788.

Copp's Hill, the Town's second burying ground, was established in 1659 on a hill named for shoemaker William Copp. Locals played on the name, dubbing it "Corpse Hill." The site soon rivaled the Common as a public venue, hosting such spectacles as the 1704 execution of seven pirates. In 1764, Bostonians celebrated the end of the French and Indian War with gallons of rum and beer and a huge bonfire fueled by forty-five barrels of tar and fifty pounds of powder. The repeal of the Stamp Act in 1765 sparked more festivities. In January 1795, townspeople feted the French Revolution by roasting an ox atop the hill.

The Mather dynasty of Puritans rests on Copp's Hill in a subterranean brick vault. Patriarch Increase Mather, minister of the Second Church, helped negotiate the new colonial charter of 1692 while a delegate to the British court. Although the charter retained Congregationalism as the "established," publicly funded church, it permitted a new freedom of religion for all Protestants against Mather's protests. Increase's son Cotton, also a Second Church minister, led Boston's rebellion against Governor Andros in 1689. Although he condoned the Salem witchcraft trials of 1692, he was more progressive in other respects, championing the life-saving new small-pox inoculation in 1721 and opening a school for black children. In 1818, his grand-daughter Hannah wrote a tract advocating expanded freedoms for females, such as education for girls and marriage based on mutual affection.

More than a thousand slaves and free blacks lived nearby in the North End's "New Guinea" neighborhood. Prince Hall, who fought at Bunker Hill, settled here as a freedman following Independence, agitating for civil rights, winning emancipation of the state's slaves in 1783, and achieving education of black children (albeit segregated) in 1787. A large black marble obelisk was erected at Copp's Hill in Hall's honor by the African Masonic Grand Lodge, the world's first black Masonic group, which he founded in 1775 after being barred from the white organization.

By 1760, about one-quarter of Boston's dead rested on Copp's Hill. Here also lie Deacon Shem Drowne, famed weathervane artisan; Edmund Hartt, whose shipyard built the U.S.S. *Constitution*; and Captain Samuel Shaw, who launched the China Trade in 1784. Today, the site contains more than 10,000 graves.

In 1659, the Town bought three acres of Copp's Hill for its second or North Burying Ground. "Corpse Hill" rivaled the Common as a public venue for executions and celebrations, especially as rebelliousness escalated.

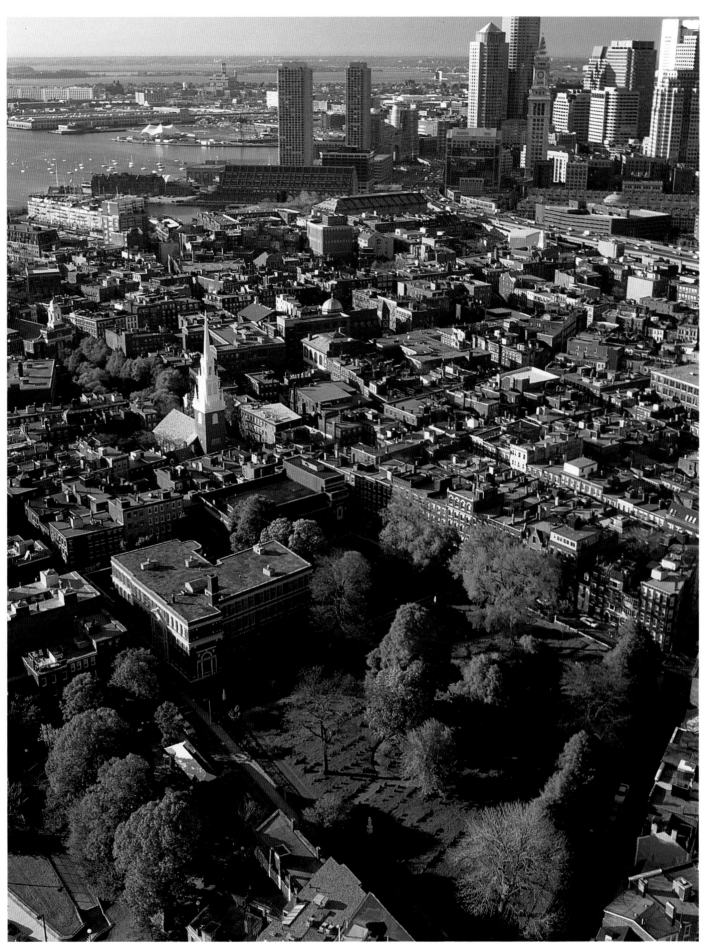

This aerial view over the North End shows Copp's Hill (bottom) and nearby Christ Church (center), built eighty years after the opening of the burying ground.

Bunker Hill

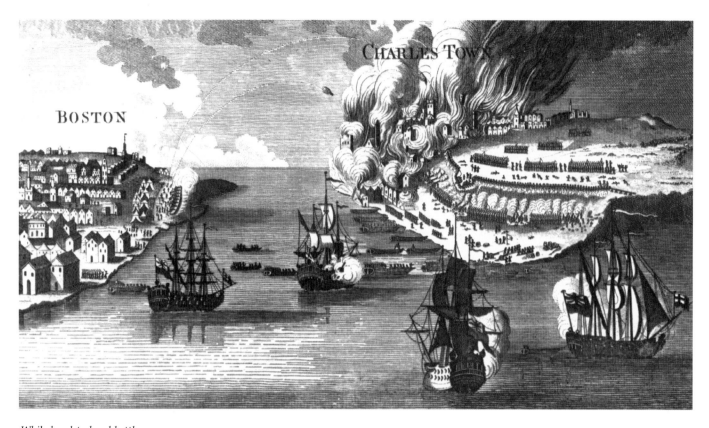

CHARLES TOWN

BOSTON

While hand-to-hand battle raged on Breed's Hill, the British bombarded and burned Charlestown from warships in the harbor and from Copp's Hill (left), a strategic location since the 1646 building of the North Battery to defend Boston.

The Bunker Hill Monument, built between 1825 and 1843, marks the site of the bloody "American Battle of Marathon." When espionage revealed that General Thomas Gage aimed to seize strategic Breed's Hill, Patriots enlisted farmer William Prescott to fortify the place with earthen breastworks. Early on June 17, 1775, General Sir William Howe sent full-dressed Redcoats up the hill in linear formations, while the British bombarded and burned the Town.

Americans ran out of gunpowder and lost the two-hour battle, but the fact that their gallant fight cost many British lives presaged future successes. Between two and five thousand Patriots engaged in the battle, although accounts proved controversial from the start. In the grisly aftermath, the British commandeered every cart and carriage to remove the dead and wounded to Boston, where "groans and lamentation" filled the streets. Patriots wrote to other colonists that they were "eyewitnesses of the most melancholy scene ever beheld in this part of the world." Churches, the workhouse, the almshouse, and private homes served as makeshift hospitals tended by physicians, surgeons, apothecaries, and women from miles around. Of 2,600 British, 504 died and 580 were wounded. Of the Patriots, some from as far away as Connecticut, 140 were killed, 271 wounded, and 30 captured. The British buried dead officers in Boston's churches and graveyards; ordinary combatants who died on the field received simple burial in holes. Mass graves of about five hundred Patriots remain. One held General Joseph Warren until after British evacuation, when his body was moved to the Old Granary.

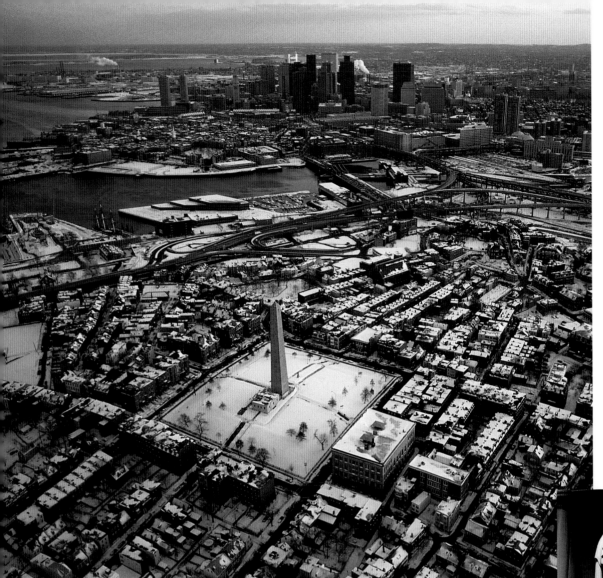

The 6,700-ton, 221-foot monument is 30 feet wide at the base, tapering to 15 feet near the apex. Inside, 295 spiral steps ascend to an arched chamber commanding panoramic views through four small windows.

General Joseph Warren (1741-1775) fell heroically in the battle, fighting as an ordinary Minuteman.

In 1794, Charlestown's King Solomon Lodge of Freemasons dedicated a wooden obelisk on the field to General Warren and his associates. Master Mason John Soley exhorted the crowd to bring children to the site to "teach them obedience to the voice of their country"and "inform them that their birth-right is Freedom." When part of Breed's Hill went up for auction in 1823, General Henry A. S. Dearborn, nephew of an officer slain in the battle, protested, "Let not the glorious sepulcher of our Revolutionary warriors be profaned." He urged "patriotic gentlemen" to buy the site "to be held sacred" as a shrine "dedicated to the Revolutionary glory which belongs to this portion of the Union." Dearborn formed the Bunker Hill Monument Association to build "a simple, majestic, lofty, and permanent monument" to "carry down to remote ages a testimony . . . to the heroic virtue and courage of those men who began and achieved the independence of their country."

Architect Solomon Willard designed an obelisk of unprecedented height, and Gridley J. F. Bryant, developer of the new Quincy granite quarries, constructed it. In grand ceremonies on the battle's fiftieth anniversary in 1825, the Marquis de Lafayette, hero of the American Revolution, laid the cornerstone; Daniel Webster urged listeners to revere the site and "to foster a constant regard for the principles of the Revolution." Construction required new technologies to quarry and transport the hard granite and to build the monument. Work proceeded slowly. Finally, in 1843, President John Tyler, his cabinet, and a dozen veterans joined a crowd estimated at 100,000 for the capstone setting. Daniel Webster, then Tyler's Secretary of State, delivered another stirring oration.

Old Ironsides

The <u>Constitution</u> carried 36 sails towering to 220 feet above deck, almost an acre of canvas on three masts, and a 160-foot bowsprit of Maine pine. The crew of about 450 included 55 marines and 30 boys.

Built of live oak, the ship was the strongest, heaviest, and fastest of its day. The name "Old Ironsides" described how cannonballs seemed to bounce off her hull. Her 24-pound long guns had a range of 1,200 yards. (opposite)

In 1794, George Washington commissioned the U.S.S. *Constitution* and five other frigates "to provide a naval armament" to defend the freedom of the high seas for the fledgling nation's growing international commerce, considered crucial to its economic independence. The nation's first frigates would be based in Boston, Philadelphia, and Baltimore. Edmund Hartt's famed Boston shipyard on Commercial Street in the North End laid the keel for the *Constitution* in 1795. The largest and widest of any 44-gun warship ever built in America, it had unprecedented strength and could achieve incredible speed. Paul Revere's Canton foundry produced the copper sheathing to fortify the hull, making the ship so heavy that she required six anchors. The warship cost the huge sum of $302,718, and the crew averaged 450 men. Many New England buildings, like the Old South Church, display craftsmanship perfected in the shipbuilding industry; but the *Constitution* epitomizes it best of all.

After several failed attempts to get the frigate in the water, massive crowds finally cheered her launching on Columbus Day, 1797. That year, the federal government spent $39,214 for 43 acres of mud flats on the Charlestown shore in order to develop its own shipyard and a moorage for the *Constitution*. Boston, with its superior deep port, thus became New England's premier maritime city, superseding its neighboring rivals — Salem, Newport, and Portsmouth.

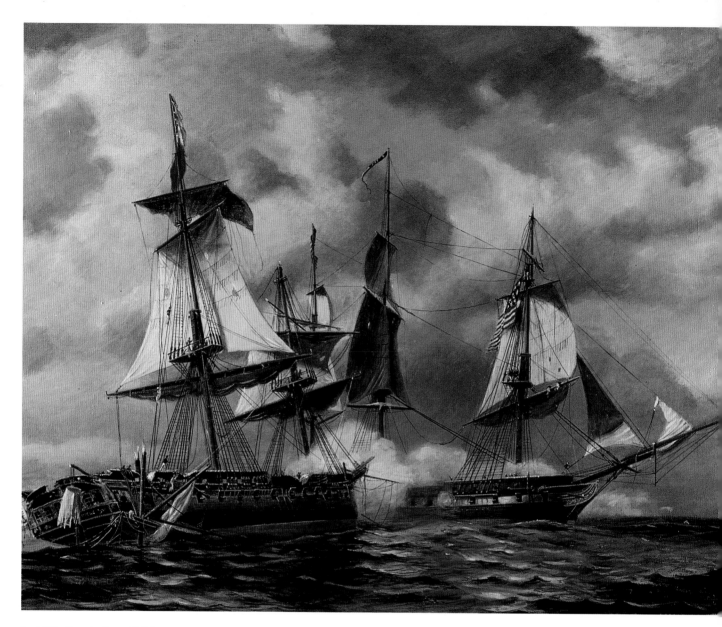

In 1812, Captain Isaac Hull's frigate U.S.S. Constitution engaged in a stunning mid-Atlantic battle against the H.M.S. Guerrière, thought to be a superior ship. "Old Ironsides" vanquished her foe in just half an hour. Five months later, she similarly defeated the H.M.S. Java off Brazil.

During John Adams's presidency, the frigate sailed for the West Indies to defend against French privateers in an undeclared war threatening American commerce. Her Mediterranean maneuvers under Commodore Edward Preble in 1803, racing at 13 knots and firing from state-of-the-art guns, quelled the lawless Barbary pirates and inspired the Marine hymn phrase, "to the shores of Tripoli." The pirates' leader initialized a draft of the peace treaty on board.

In the War of 1812, the *Constitution* met the formidable British navy off New Jersey. Later, she got the nickname "Old Ironsides" after withstanding cannon from H.M.S. *Guerrière* off Nova Scotia. The British captain declared, "Huzzah, her sides are made of iron." The *Constitution* bore down on *Guerrière* and pounded her with massive broadsides, wasting the opponent in less than an hour in a stunning victory.

Even more triumphant encounters ensued under Captain William Bainbridge that December near Brazil, when she subdued the 47-gun *Java*. Two years later the *Constitution* attacked the *Cyane* and the *Levant* off Portugal, spreading the frigate's fame internationally and helping the United States successfully conclude the war with the 1814 Treaty of Ghent, again confirming American Independence in the face of British aggression.

Although the champion "Old Ironsides" has never been beaten or boarded by an enemy, she once flirted with destruction. In 1830, rumors that the Navy contemplated

condemning the ship inspired a young Harvard student, Oliver Wendell Holmes, later the renowned physician and professional "Boston Brahmin" writer, to write a poem rousing national sentiment to save her. Reprinted in newspapers and circulated on handbills, the poem succeeded. A restored and refitted *Constitution* plied the Mediterranean, the Pacific, and the Atlantic, especially on missions against the illegal international slave trade.

Retired during the Civil War, the frigate became a training station for naval officers in Newport, Rhode Island. But by the late nineteenth century she was languishing in Portsmouth, New Hampshire, decay again threatening. Congressman John F. "Honey Fitz" Fitzgerald intervened with the secretary of the navy and Congress to save the frigate in time to move her to her old home port for her 1897 centennial. Restoration did not begin until financed in 1925 by schoolchildren's pennies, larger donations, and government appropriations. Returning to service, she sailed a three-year triumphal tour of American ports before finding permanent dockage in the Charlestown Yard in 1934. The U.S.S. *Constitution* remains the world's oldest fully commissioned warship, exemplar of America's first venture for international power. From 1993 to 1996, the Navy undertook a $3.75 million renovation for her 1997 bicentennial. Preservationists based their meticulous work on the plans of a sister ship that was captured by the British Navy during the War of 1812 and used as a model for building strong, fast royal frigates.

The Charlestown Navy Yard, a historic site even without the *Constitution*, bustled again with industry during World War II, building and repairing ships and producing related materiel for yet another international challenge to freedom.

Painted black, the Constitution's hull signified her fearsome power and indestructibility. Each Fourth of July, the frigate ceremonially turns around in the harbor, exchanging artillery salutes en route with the Castle Island fort and with other vessels.

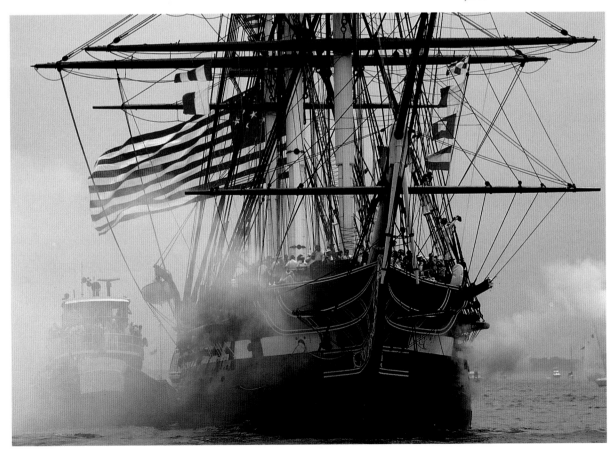

Epilogue

Freedom Trail sites offer glimpses into the wealth of history in and around Boston. But history here extends beyond the Puritan town's limited sense of "publick liberty," and beyond Revolutionary demands for provincial liberty. A later generation made Boston the center of a moral crusade to extend freedoms to slaves. Just as abolitionism aimed to compensate for the Founders' failure to legislate comprehensive freedoms, the Black Heritage Trail complements the Freedom Trail with sites associated with the struggle to free slaves and expand civil rights.

After victory in the War of 1812 confirmed America's Independence, Boston's revived prosperity sparked a cultural renaissance. Having sloughed off colonial status, the burgeoning Town became a City in 1822. New generations strove to make Boston the "Athens of America," cultivating the literary "Flowering of New England" from the Old Corner Bookstore.

But it took more than enlightened thought to effect concrete change. In 1783, the Massachusetts Supreme Court ruled slavery unconstitutional. In the 1820s, freedmen resettled in Boston, because they would not have to wear the shoulder patch, required in the South, proclaiming them free but leaving them vulnerable to seizure as fugitives. Yet even Boston's blacks could not rest easy; only tight community vigilance countered the ever-present threat from bounty hunters.

The Anti-Slavery Society viewed slavery as a moral outrage. William Lloyd Garrison denounced slavery's inclusion in the Constitution as a "covenant with Death." He spoke out, often at personal peril, from his first stirring speech in 1829 at the Park Street Church to others at Beacon Hill's African Meeting House and Faneuil Hall, frequently sharing the podium with fugitive slave Frederick Douglass. Garrison tested the limits of freedom of the press in 1831 when he founded the *Liberator*, a newspaper that called for immediate emancipation.

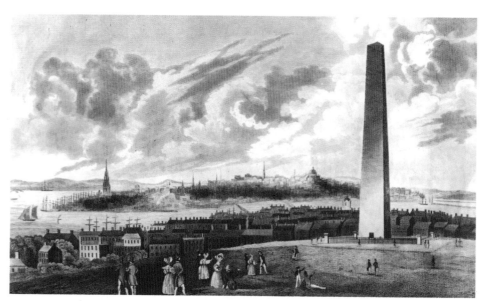

By 1830, the Bunker Hill Monument rose only forty feet, "surrounded by the massive stones . . . like a sublime ruin." Construction stalled until Sarah Josepha Hale, editor of Godey's Ladies' Book, raised $150,000 to complete it.

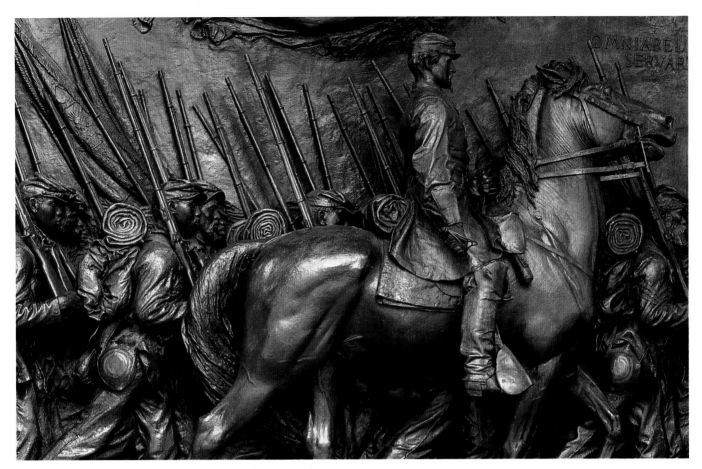

Similarly, William Ticknor braved more than controversy in 1833 when he displayed Lydia Maria Child's tract, *An Appeal in Favor of That Class of Americans Called Africans*, in his Old Corner Bookstore—a racist mob smashed his windows. In 1835, Mayor Theodore Lyman gave Garrison asylum in the Old State House as another racist crowd threatened to dye his skin black before tarring and feathering him. Fortunately, Boston's institutions and officials generally supported the abolitionists.

Faneuil Hall continued to be a forum for freedom and controversy. Here, in 1837, Wendell Phillips declaimed against the assassination of anti-slavery publisher Elijah Lovejoy in Illinois. But two years earlier the hall had hosted a pro-slavery crowd; and, ironically, much of Peter Faneuil's fortune had come from the slave trade. Over the decades, feminists and anti-feminists, Democrats and Republicans have all taken the podium in this "Cradle of Liberty."

In 1840, Garrison braved schism within the Anti-Slavery Society by calling for women's rights. His female abolitionist friends chafed under the silencing of their speech, particularly by the local Congregational ministry, and the policy of segregating them in Faneuil Hall's galleries. Lydia Maria Child spoke of the problems she faced as a woman writing about slavery.

As soon as Lincoln issued the Emancipation Proclamation in 1863, abolitionist Governor John Andrew authorized recruitment of the first regiment of black volunteers, the 54th. On May 28, 1863, with more than a thousand men from across the North, led by Colonel Robert Gould Shaw, the 54th marched in review past the State House and on to fight in South Carolina. Boston's two Freedom Trails intersect on the Common in front of the State House at Augustus Saint-Gaudens's bronze equestrian statue of Colonel Shaw and his men. Victory flies above, despite the tragic casualties suffered by the regiment. The monument's unveiling on Decoration Day, 1897, featured orations by William James and Booker T. Washington.

Formed by abolitionist Governor John Andrew, the 54th drew recruits from as far away as the midwest and Canada, including Frederick Douglass's two sons. Cheered on by crowds singing Julia Ward Howe's new "Battle Hymn of the Republic," they sailed in 1863 for South Carolina. There, Colonel Shaw, two white officers, and 31 troops fell while storming Fort Wagner.

47

The Common remained a public, ceremonial place and a prime site for many other historic monuments. Beautification of Boston's old burial grounds from the 1830s on included resetting stones to permit visitors to stroll new paths over old graves; trees and shrubs were "intermingled to afford a delightful shelter to those" exploring "the moss-covered memorials of the past."

Time, reuse, and abuse eroded many Freedom Trail sites throughout the nineteenth century, their significance ignored as ideas of progress favored the new over the old. Historic preservationism of major Revolutionary sites did not appear until the 1870s, when important buildings were threatened with destruction. The 1876 centennial stirred interest in history set in place. That year, Ralph Waldo Emerson, Oliver Wendell Holmes, Wendell Phillips, James Russell Lowell, and other notable Bostonians formed the Old South Association to restore the church that had served as a "cradle of liberty" whenever Faneuil Hall had proved too small. The Old South had barely recovered from British vandalism when fire nearly destroyed it one winter night in 1810; still, in spite of the damage, services continued until the congregation relocated in 1872 and it became a temporary post office. Speculators planned to demolish the structure for commercial development until preservationists stepped in.

Similarly, an 1882 campaign thwarted the destruction of the Old State House to improve traffic, as well as a bid to have it moved to Chicago. Small businesses had occupied the building since the 1840s, plastering it with unsightly billboards. Preservationists won another battle when the Bostonian Society restored this structure as a history museum.

In 1902, Paul Revere's great-grandson rescued his ancestor's decaying home from demolition. Architect Joseph Chandler restored Boston's only remaining late-colonial wooden structure, eliminating traces of various reincarnations as an immigrant tenement, cigar factory, candy store, green-grocery, and bank. On the 1908 anniversary of the famous ride, the Paul Revere Memorial Association opened the house as a museum.

The past lives on along Boston's Freedom Trails. Amid the din of a bustling, modern city, these historic sites speak to us, telling stories of those who quested for freedom for themselves and future generations.